ANGRY PEOPLE IN LOCAL NEWSPAPERS

ANGRY PEOPLE IN LOCAL NEWSPAPERS

ALISTAIR COLEMAN

MICHAEL JOSEPH
an imprint of
PENGUIN BOOKS

MICHAEL JOSEPH

UK | USA | Canada | Ireland | Australia
India | New Zealand | South Africa

Michael Joseph is part of the Penguin Random House group of companies whose
addresses can be found at global.penguinrandomhouse.com.

Penguin
Random House
UK

First published 2018
001

Set in 10.5/12.5 pt Times NR MT Std
Typeset by Jouve (UK), Milton Keynes
Printed and bound in Great Britain by Clays Ltd, Elcograf S.p.A.

A CIP catalogue record for this book is available from the British Library

ISBN: 9780241356623

www.greenpenguin.co.uk

MIX
Paper from
responsible sources
FSC® C018179
www.fsc.org

Penguin Random House is committed to a
sustainable future for our business, our readers
and our planet. This book is made from Forest
Stewardship Council® certified paper.

Brits lose their rag in local rags

Britain is a country on the edge.

A country lost in its own impotent rage.

And it's not because of the big issues in the news like the state of the NHS, an impending Third World War, Brexit and . . . err . . . Brexit.

It's also about those trivial things that get up your nose – the bins not being emptied on the right day, stepping in dog poo for the third time this week, getting an unfair parking ticket, or finding some squamous nightmare creature from the pits of Hell lurking at the bottom of your tin of Heinz Cream of Tomato soup.

Most of us know how to react when a politician lies. You get to vote them out at the next election, and in the meantime you can moan about them in the comments section of *Mail Online*.

But when your bus timetable is suddenly changed, bringing minor inconvenience to your daily commute; or if – say – you received a £900 bill from your cable television supplier for adult films you swear blind you didn't watch, where do you go?

Obviously, the correct and logical answer to these questions is the bus company and Virgin Media, but angry people tend not to be logical, and the people who wronged them are invariably the last people from whom they seek satisfaction.

Angryism has changed along with the times.

While furious local councillors crouching over potholes like they're

going to the toilet are still the staple of local newspapers where editors have to somehow fit thirty-two pages of stories and photographs around the adverts and make money in the process, there is now the very real chance that a particularly ridiculous photo story will go truly viral, making editors and accountants very happy indeed.

For one thing, angryism perfectly illustrates the British habit of 'I don't like to complain, but . . .', and combines it with the off chance that there could be a few quid at the end of this while the person who doesn't like to complain makes a concerted bid to join the British Olympic complaining team.

A nice hamper from the supermarket, perhaps. Or the bus company offering a chauffeur service from your front door, for life. This never happens.

I've been doing this long enough to know that when they say, 'I only ever wanted an apology,' their eyes in the accompanying photograph say, 'And a gift voucher would be nice as well.'

Add in lunatic letters, daft headlines and some of the dullest news stories ever committed to print, it makes you wonder why local newspapers are struggling to survive.

They're part of us. We cannot afford to lose them.

But if we do lose them, I'll be the first to be photographed pointing angrily at the space where my local rag used to be. Because that's how it works.

Food

I spent my formative years when I should have been at university working for an obscure branch of the UK government tasked with the job of counting Britain's cows.

After I had come up with a one-hundred-per-cent inaccurate figure of the number of cows in the United Kingdom (rated by whether they were alive, or dead and in an industrial-sized freezer somewhere), I would telex this data to an office in Brussels, where, for all I knew, they put it straight into the bin.

Yeah, telex.

The reason I am telling you this is because these three years of my life were not entirely wasted; they were an education.

And the thing that I was educated about is this: What goes into your food.

Distilled down to a single sentence, this knowledge boils down thus: You do not want to know what goes into your food.

That being the case, I have made it my lifelong mission to try not to find out what goes into my food, because life is short, and you shouldn't make it any shorter by – for example – worrying that you might be munching through an animal's anus with your Friday-night dirty kebab.

Because there's every chance you might be eating anus, and unless you have an extremely varied personal life, that's not the kind of thing we do in polite society.

Unfortunately, people **do** have a regrettable habit of finding out what goes into their food, and when they do, it makes them very angry indeed.

Then they go to their local papers to make sure everybody in the whole world knows what they've found in their food, and with the thought that a four-figure compensation cheque at the end of it wouldn't be the worst outcome.

Food fury has a very special place in the concept of angry people in local newspapers, because it is one-hundred-per-cent suited to angry faces.

Food items such as the tinned meat pie with additional meat factory worker's thumb photograph very well alongside the disgusted consumer who is grappling with the thought that they may have eaten a finger well before the thumb revealed itself, along with the very clear thought of getting enough compo out of Global Tinned Pies And Lead Figurines Ltd to go and retire on an island somewhere.

 In reality, Global Tinned Pies And Lead Figurines Ltd will offer them a replacement pie and a £10 'goodwill' gesture, entirely in Global Tinned Pies And Lead Figurines Ltd gift tokens.

And that is all you will ever get if you complain through the correct channels.

So that's why – if you find a packet of chocolate biscuits which have been coated with ham instead of chocolate – your first port of call should be your local newspaper (see page 179 for a perfect example).

There are two types of people who go to local newspapers when they have found something disgusting in their food:

1. People who want to warn other people of the potential horrors waiting inside a popular brand of instant coffee that could make you glow in the dark. This accounts for 0.00001 per cent of 'something wrong with my food' local newspaper stories;
2. People who want compo (the other 99.99999 per cent of these stories).

The oxygen of publicity, this 99.99999 per cent think, will raise the offer of a free pie and the insulting goodwill gesture to something closer to expectations, to what: a Caribbean beach holiday to get over the shock, and a free pie?

Unfortunately for them, the publicity only ever gets them the vouchers and public ridicule.

But that's not the end of the story when it comes to food fury in local newspapers.

It's one thing finding a whole deep-fried seagull in your [Insert random US state here] Fried Chicken take-out; it's totally another if you've been the victim of bad service.

Bad service in the food industry is up there with direct threats of death against you and your entire family for the very worst thing that can happen to you, and is treated as such in the local press.

Charged 8p for sauce at your local takeaway? You'd better have *The Advertiser*'s newsroom on speed dial, because they'll be straight down there with a photographer (see page 181 for proof).

Somebody drew a knob on the inside of your burger box? You'd better have rehearsed that angry face because that's one photo that's going viral right around the globe.

Ah-ha! I hear you say – there should be billions of these photographs, because every single time I go shopping, I am insulted by shopkeepers and have coffee shop people openly putting salt in my cappuccino and writing the words 'Big-nosed tosser' on my cup.

But you are wrong. Britain is a culture that nearly-but-not-quite says something when put out – even more so when it comes to food service.

How many times have you been served completely the wrong order, at a temperature some ten degrees colder than Siberia, but tell the waiter everything's O K when they come to check on you?

ALL THE TIME, that's how often.

That's why bad food service photographs are something special and to be treasured. These people have broken the mould, they've gone out there and said what every man jack of us has always wanted to say.

And they've got free pie.

Dive-bombing gulls ruffle the feathers of cafe owner

'Kamikaze' gulls have prevented a restaurant from serving food on its upper terrace.

Dive-bombing gulls have been causing havoc for customers at a beach cafe, as well as injuring themselves.

The owners of the establishment have put up signs asking customers not to take food up there, but are now looking at ways to combat the problem.

The owner of the cafe, Mr Percy, said he did not have much choice in his decision.

"it's a bomb site"

'We've stopped customers from eating upstairs due to our experiences over the last few years,' he said.

'We've been here six years now; the first year was fine, second year they started to suss it out and over the last couple of years they've interfered. They dive bomb down, straight in, they aren't that intelligent though because they can't get back out. They'd get stuck and smash against the glass, we'd find blood and all sorts up there. Of course, they'd also be nicking people's food

and, if a table hasn't been cleared quick enough, it's a bomb site.

'So I decided last year no food upstairs, just drinks, coffees, beers etc.'

Mr Percy is considering ways of keeping the gulls at bay.

'We plan on rectifying the problem as soon as possible with either wire or netting, as it works elsewhere,' he said.

'Short of someone up there shooing them away all the time, there isn't much else we can do for the moment. It's a real shame that customers can't eat up there.'

Mr Percy believed he knew the reason the gulls had been targeting the cafe.

'This all stems from someone feeding the birds every day for years. They would put bread up along the wall,' he said. 'The seagulls know it's a feeding station, so they've been coming back for years and years. We know the seagull that does it the most, he's got red markings on his face, we'll see if he comes back this year.

'The decking out the back which was OK for food is still open, but they've started to suss that out as well, they all line up along the rail. We are now having to forever shoo them away.'

Although some customers have been disappointed at not being able to take in the views from the roof terrace while they eat, Mr Percy did not believe it would cause any damage to business.

'Some customers have moaned like mad,' he said. 'But I think they would moan more if they're just having a bite from a burger and a seagull comes snappy, snappy.

'I don't think it will affect business, maybe a couple of people might think, "I'm not going there".'

"they're flying vermin and they can go away"

'I do feel sorry for the seagulls, but they're flying vermin and they can go away.'

Sports coach irate with KFC because staff 'didn't cook him chicken'

Mr Roberts says his experience was unacceptable – but fast food giant says incident 'didn't happen'.

A sports coach claims he rocked up at his local KFC – only to be told by staff they wouldn't cook him any chicken.

Mr Roberts is still seething with the fast food giant about what went on that night. The sports coach turned up at 10.30pm one night this week looking forward to some freshly cooked, hot, fried meat. He claims he was told his chances of a meal were slim because of the number of customer orders piling in.

But, fuming, he didn't think that was a good enough excuse.

" I'm still quite irate

He claimed things then went from bad to worse when staff told him he would have to wait potentially up to half an hour – by which point the store would be shut for the night.

'They would have been closed!' he said.

He alleges that when he got to the counter, all staff could offer him were already prepared chicken wings as they were ready to lock up. Mr Roberts says he wasn't the only one annoyed – claiming that at least one customer stormed out.

'I'm still quite irate,' he said. 'It's just unacceptable.'

" It's just unacceptable

He claims he was offered a discount but thinks it wasn't good enough. If it had been a fish and chip shop, he said, he'd have understood, but thought things would be different for a big chain.

'Not good, to be honest,' he said. 'They could have told us when we walked in.'

Not only that, but he said that staff had been 'a bit rude'.

It's been a tough time for KFC this year, with some even calling it 'the great chicken famine of 2018'.

Many branches were low on stock last month after bad weather delayed their delivery trucks, leaving them offering only a 'limited menu'.

Back in February, KFC stores were closed all over the UK due to supplier issues and local police took to Twitter to tell people off for calling them about closures.

Some people are clearly a bit too passionate about popcorn chicken.

Mr Roberts was more pragmatic. In true sports-coach style, he said: 'Fail to prepare, prepare to fail.'

Plymouth Herald reached out to KFC, which spoke to the branch in question and could not corroborate Mr Roberts' story.

A spokesman for the company said: 'As far as we can confirm, this didn't happen.'

Toddler banned from vegan child's birthday party for wearing cow onesie

A young mum from Southend has been describing her outrage after her eight-month-old daughter was banned from attending a vegan child's birthday party as she was wearing a cow onesie.

Ms Hyde told our Chief Reporter that she arrived at the birthday bash with her daughter wearing an adorable cow onesie, not realising that birthday boy is being raised as vegan by his mum.

She said: 'As soon as I arrived at Funky House Soft Play in Ashingdon, I started getting filthy looks from a lot of the mums there. I only realised afterwards that they were all vegan as well.'

" I started getting filthy looks

'I didn't even get my own coat off before the mother who had organised the party came over and asked me to leave – she was really upset and told me that I was just plain rude to dress my child that way.

'It made me so angry when she said that I was mocking her beliefs and I just walked out with my little girl.

'A few hours later, she texted me and said that my child was no longer allowed to play with her child at the local playgroup where we met. She's off her rocker.'

We contacted Mrs Soy-Abbinton, and she told us that she 'stands by' her decision.

She added: 'There's no way that she could plead ignorance and say that she didn't know that I am a vegan and that I am raising my child to follow these beliefs.

'I make it my business to let everyone in my circle of friends know on a regular basis, and my Facebook cover image is a large meme saying "Hardcore Mega-Vegans Do It All Night Long".'

'I'm sorry to say that she is plain ignorant and I can't have her daughter anywhere near my Eddie any more.

'You wouldn't take your child to a Muslim birthday party dressed as a side of gammon after all.

'That cow onesie gives out the impression that it is OK for humans to skin a real cow alive and wear the skin for their own entertainment.

'I still feel sick now just thinking about it and I am considering my options. My lawyer has already told me that it could constitute a hate crime.'

Yuk! There are maggots in my Fray Bentos pie

A disgusted father was shocked when he found live maggots in a Fray Bentos pie moments before cooking it for his children.

Stuart discovered the grubs wriggling around inside the pie in front of his horrified wife Jane and their three children.

The father of three was about to cook the Fray Bentos steak and kidney pie on Monday evening when he noticed there were clumps of pastry missing.

When he looked more closely at the dish he was shocked to discover three maggots in the filling.

'We were about to put it in the oven but we noticed there was a bit of pastry missing and then we saw the maggots,' he said.

'We were going absolutely mad. We were disgusted. We took lots of pictures of it but when we got in touch with Baxters, who make it, they fobbed us off.

'I will never buy them again. I will never buy a pie out of a tin again. It is disgusting. It could have made my kids ill because at the start I just thought some

of the pastry casing was missing but then I looked further. So the maggots must have eaten it away.

'It is very gross. I only bought the pie days before. It is really horrible.

'I dread to think how it happened. It might have happened in the factory. We think there may have been flies in the factory and they may have laid their eggs in the containers there.'

The family, who live near Evesham, bought the £2.49 pie from their local Iceland branch last week.

Full-time mum Jane added: 'I do not think the store is at fault at all. They cannot see what is inside the pies. I have kept it for evidence for the moment.'

> "I will never buy a pie out of a tin again"

> "I dread to think how it happened"

There were three maggots found in the pie and yet it was well within its best before date.

A spokesman for Fray Bentos, which is owned by Baxters, said: 'We have been informed of the claims made by the family regarding one of our Fray Bentos products and are treating their complaint as a priority.

'Our immediate request on being contacted was to ask for the product to be returned so we could instigate an internal investigation into the can and its contents.

'As of yet we have not received the product, therefore it is impossible for us to speculate further on these claims.'

Couple's shock after 'vegetarian' product incorrectly labelled

A woman from Trowbridge was shocked to discover that the supposedly vegetarian snack she bought from a Warminster supermarket contained meat after being incorrectly packaged.

Tiffany and Philip, of Trowbridge, visited the Warminster Morrisons on a Thursday in January to do some grocery shopping. When the couple returned home they tucked into a pack of what they thought were Morrisons' cheese and onion rolls – but to the horror of Tiffany, who describes herself as a demi-lacto vegan who eats dairy products, the rolls turned out to contain pork sausage meat.

She said: 'I felt physically sick when I realised. It is totally unacceptable that this would happen. For thirty years I have

been very careful about what I eat because it used to be so difficult to find food when you went out that did cater to my diet; nowadays when you buy something you expect it to be what it says.

" when is a label not a label?

'In our house we keep the meat and my food separated, we even use different chopping boards to prepare our food. The last time I remember eating meat is when I was pregnant with my son. Since then I haven't eaten any, my body just rejects it.'

Tiffany said the response from Morrisons, which referred to the mistake as an 'incident', was not good enough, adding that she expected more from the company.

Philip said: 'My partner hasn't eaten meat for thirty years, and when it turned out the snack contained pork she was very sick and started suffering from major stomach cramps. I contacted the Food Standards Agency and said that it was lucky it wasn't a nut allergy or something similar.

'It just raises the question – when is a label not a label? We have the packaging still and it clearly says cheese and onion, so when do you stop believing in what the label says?

'We were considering shopping at Morrisons in Warminster instead of our usual Tesco in Trowbridge but now I don't think we will be returning.'

" I don't think we will be returning

In a statement from Morrisons, the company apologised for the error and emphasised that stopping mistakes like this happening is important to the supermarket chain.

A spokesman said: 'At Morrisons, we are very aware that for various reasons our customers may wish to avoid certain foods for personal beliefs, and therefore we take the correct labelling very seriously indeed.

'We were very sorry to learn that the customer was sold an incorrectly labelled product, and have offered our sincerest apologies. We will ensure extra vigilance with regard to the correct labelling of these products, and will closely monitor it to make sure it doesn't happen again.'

Family eat Quality Street Christmas dinner after pub 'ruined' festive day

A family ended up eating Quality Street to fill themselves up after a pub served up a Christmas lunch they say was substandard, cold and late.

Emma from Gorse Hill booked in a day of festive fayre at Covingham Drive's Messenger pub.

For £37.99 the Greene-King-owned eaterie offered a three-course set menu, complete with mince pies and coffee.

But instead of a plateful of Christmas cheer, Emma said the Messenger served up rock-hard stuffing balls, cold dinner and lengthy delays.

'They ruined our Christmas day, without a doubt,' Emma said.

'It was a joke, you don't want to cause a fuss but when

you have waited an hour for a bowl of soup and two hours for a main course you have to.'

Emma's family, which included her two teenage sons and parents, were left hungry after the Christmas dinner debacle.

'By the time I left I was so angry, I just wanted a cup of tea. You don't imagine you'll be eating Quality Streets for your main meal at Christmas.'

By the time I left I was so angry, I just wanted a cup of tea

When the eight-strong party arrived for their 2pm booking, Emma said her family were told they couldn't sit down until cutlery was laid out.

'At 2pm there was no sign of cutlery, my mum has a disability and my husband has bad sciatica so I decided we were sitting anyway, regardless of cutlery, by 3pm. By 4pm we were still waiting for our main meal even though three members of staff had come over and checked.

'I had to stab the stuffing balls like you would spear a fish and they were so hard you felt like they were going to break your teeth. The parsnips weren't so much caramelised as burnt, the other food was cold, it was just a disaster.'

Emma said she was promised a discount which never materialised.

'I was told the manager had already cashed up for the day. They offered me a bottle of wine when I don't even drink, which is a sign of how ridiculous it was.

'I paid an £80 deposit and the total came to £300 when only one of us ate our meal. I feel ripped off. There was another table that had been waiting a similar amount of time to

us, and the table next to us had a refund for the desserts that they had been waiting over an hour for and they gave up and walked out.

" I had to stab the stuffing balls like you would spear a fish

'I felt like I had let my family down because I booked the place, and to see my parents not eating because of the cold food was awful,' said Emma.

The Messenger's Facebook page has since had more complaints from fellow diners.

In a Facebook post Messenger's manager apologised for 'letting down' the diners.

'Folks. I want to apologise for what happened yesterday and I promise you that no one is more let down than myself as a manager. I have no idea what went wrong in the kitchen but for you people that eat with us regularly, know that this is not like the Messenger. I know I can't put yesterday right as it's been done but I will be in contact with you individually to discuss this matter further. I can't apologise enough to each and every one of you.'

A spokesperson for the Messenger pub said: 'We pride ourselves on providing excellent service for our customers and we apologise that, on this occasion, we did not meet the high standards expected of us. We are reaching out to the small number of affected customers to offer our apologies and gestures of goodwill and we hope to resolve this to each customer's satisfaction, so that we can look forward to welcoming them back to the Messenger in the future.'

Father's disgust at rubber dummy in bag of Iceland rice

A family got more than they bargained for at dinner time when they discovered part of a child's dummy in a bag of rice from Iceland.

Justin noticed a strange clear rubber object as he was sitting down to eat with his partner and their children.

Only when he removed it

from the food did he realise it was the rubber teat from a dummy.

'It's pretty shocking, I was disgusted,' said Justin.

'Think of the possibilities: I've got twin daughters, what if one of them had swallowed it or choked on it. The whole ordeal made me feel sick inside.'

The clear appearance of the dummy meant it was not

possible to spot in the food.

'My partner had laid it all out on the table and it was only then that I spotted it. I said: "What on earth is that?"'

'It was about an inch long, clearly rubber and it had a hollow bit at the top where the plastic would go in. We were shocked.'

Justin's partner, Hayley, had bought the bag of egg fried rice from the Iceland store in Gorse Hill.

It wasn't the first time she had picked up that particular item so she didn't expect to have any problems.

Justin and Hayley rang Iceland straight away to complain about the surprise discovery.

They were given an email address and asked to send photos but when they did, the response they received did not

> "The whole ordeal made me feel sick inside"

reassure them that the company was taking the matter seriously.

Justin said: 'We rang customer services and they got us to email them the photos. To be honest the answer we got was pretty shoddy – they just said they would look into it, no apology at all.

'It's really poor customer service, especially from a national company: their attitude to the complaint was totally unacceptable.'

Justin is now expecting to receive some packaging from the firm so that he can send back the rice and the mystery rubber object to be looked at.

Asked whether he and his partner would continue to shop at the store, Justin said it would all depend on how the company handled their complaint moving

> "their attitude to the complaint was totally unacceptable"

forward, but that so far he hadn't been impressed at all.

A spokesman from Iceland said: 'Please be assured that we take all complaints extremely seriously.

'We can confirm that the customer has been in touch with our customer care department regarding the foreign body. We have arranged for the item to be collected in order for our supplier to carry out a thorough investigation.

'As soon as we have the results of this investigation we will get back in touch with the family.'

Fury after Morrisons wouldn't sell couple meat pies before 9am

The meat pies were within sniffing distance – but staff told couple at 8.45am they could not be sold for another fifteen minutes.

'I wanted eight large sausage rolls and two steak bakes,' said Linda, from Thorntree.

'It was 8.45am and there were no pies at all displayed. I could see bags and bags of pies, all wrapped up on cages behind the counter. The trolley was ready to be pushed out.

'But when I asked for the pies, I was told: "We can't sell the pies until 9am." I could have had a fruit pie, but not a meat pie.'

A queue of five other confused customers formed at the 'Oven Fresh' counter in Berwick Hills Morrisons to demand their pastry fix last Wednesday.

But staff were determined to

abide pie the rules, telling customers the store had a new 'no meat pies before 9am' policy.

'If they hadn't been cooked, that would make sense,' said grandmother-of-four Linda. 'But the fact that they were baked, well – it's ridiculous.

> **the fact that they were baked, well – it's ridiculous**

'If I could've reached over, I would have grabbed them myself. I wasn't waiting fifteen minutes so I went to Cooplands. I was disappointed to say the least.'

She added: 'They are dictating to me when I can buy pies and when I can shop.' Husband Tony, who eats fish and chips three days a week and rarely touches pastry, branded the decision 'stupid'.

> **They are dictating to me when I can buy pies**

The customer said: 'When you're faced with that situation at the counter, you start thinking: "Is it *Candid Camera*? Is it April Fool's Day?"'

'You can have fruit pies, but you can't have meat pies! We have always been able to get the pies before 9am. The decision makes no sense. I can't see any logic.'

Morrisons told *The Gazette* there is no 'hard and fast policy' and meat pies are simply baked for 9am to match customer demand.

But Tony suggested a more sinister explanation.

'There's more to this,' he said. 'Morrisons have got their own agenda. They don't want people to know about it. They have given too many ridiculous stories about why. They contradicted themselves over and over.

'Who do they think us customers are? We are the people paying their wages.'

The supermarket chain, with 500 stores up and down the UK, has now swallowed a piece of humble pie and issued an apology to the couple for the mi-steak.

A spokesman said: 'It appears that in this case we should have sold the customer their pies. We apologise for any inconvenience it might have caused.'

Transport

It is part of the human condition to travel.

See the world, migrate thousands of miles, or just take the bus to the corner shop for a lottery ticket and a four-pack of their second cheapest lager.

So, with roaming in our very genetic make-up, why the hell does travelling make us so damn angry?

We're not talking road rage levels of fury. And not even about taking a plane, flying it all the way to your enemy's house in order to drop two tons of cow manure down their chimney (although I am very much attracted to this idea in regard to a cowboy builder who still owes me a large amount of money), mainly because most of us have no access to aircraft or industrial quantities of animal turds.

What we're talking about is minor inconvenience because the council's moved your bus stop 200 yards further down the road; or the fact that a railway guard has dared to ask to see your ticket although it is your right as a Sovereign Citizen of This Proud Nation never to have to bother with such fripperies as 'paying your fare'.

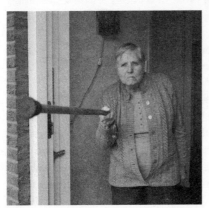

That's the time to polish up your best pointing finger and get down to the bus shelter, or as close to the railway station as the court order will allow, and get your face into the local rag.

The main point you need to get across in these stories is a simple one: How those pencil-necked desk jockeys at the bus company have completely ruined your life because the

bus stop is no longer directly opposite your front door. You may even throw in the winning phrase 'I'm a prisoner inside my own home,' even if you are photographed clearly outside your home. I promise you, nobody will notice.

Even if the bus company hasn't moved the bus stop from directly outside your door, you may still approach the local newspaper to complain about the bus stop directly outside your front door, mainly because you can't walk about naked in your own home with all the lights on and the windows open.

'I'm a prisoner in my own home,' you can tell them, naked as the day you were born, clearly outside your own home. I'm telling you, this would make the front page.

But it's not all about buses. There are people with strong opinions about cars, planes, trains and [looking to future editions of this book] spaceships and matter transporters too.

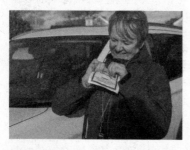

And if there's one thing that is guaranteed to fill those thirty-two editorial pages of newsprint, it's parking.

People waving parking fine notifications are the bread and butter of local journalism, to the point that news titles are now stationing reporters by the exits and ticket machines at municipal car parks, dealing with thousands upon thousands of aggrieved motorists clutching £100 parking penalties to their chests, and looking like they've been slapped in the face.

Parking outrage has got to the point, in recent months, where staff photographers at your favourite local newspapers have started carrying around a car door as part of their kit, so angry drivers can look like they are waving their letter from Total Bastard Parking Solutions out of a car window because their own motor is now a one-foot cube of crushed metal after they overstayed at their local out-of-town retail park for three minutes.

I'm a solutions-oriented kind of person, and my solution here is a simple one: Try not to get fined for parking badly.

My other solution is equally simple and a million times more exciting: DO TRY to get fined for bad parking, then go to your local newspaper and get photographed pointing wanly out of a fake car window at your parking ticket, with a look on your face like you've been licking a leaky battery.

This approach does not, however, work well when it comes to fury over problems with air transport, mostly because airports tend not to let randoms roll up on the tarmac so that they may be photographed looking angrily out of a plane window.

That calls for more inventive posing. And the one that has become standard for all holiday and flying badness is to be photographed in your back garden leaning on your luggage.

It is the rule that if the story is about OUR HOLIDAY HELL the entire party must be present for the photoshoot, all leaning on a suitcase, all still in their holiday clothes, and all with faces like a long wet Sunday in Benidorm, just after they'd munched down the all-you-can-eat buffet that comes with free food poisoning.

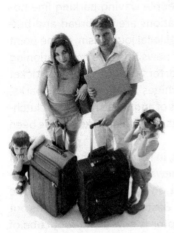

Exception: If the story is about lost luggage, then the photoshoot must take place with no items of luggage at all, to show the readers that the luggage has indeed been lost. All participants must be wearing the same clothes they've worn for the entire two weeks in the Spanish sun, no exceptions, and the newspaper may even break the budget with a scratch-and-sniff edition.

Look, those are the rules. We don't just make this stuff up, you know.

Further rules of transport-related fury:

1. Stories about yellow lines MUST include the wronged party squatting and pointing at said lines, done-a-poo style.

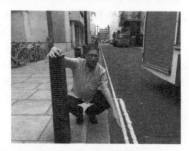

2. Commuters must be seen wearing a full suit and tie and carrying a briefcase, no exceptions.

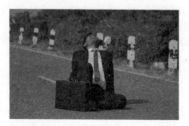

3. Any story about reductions to bus services MUST have a bus in the background, even if the story is about there being no buses at all. This is one of the few occasions where the 'Say what you see' principle does not apply.

4. Cyclists MUST wear Lycra, and the comments left open on the story to invite insults from motorists.

Happy travels!

Fury at plans to spend £54,000 on bus signs

Give us more buses instead, angry villagers demand.

People living in one of Cambridgeshire's biggest villages are hopping mad at plans to spend £54,000 on installing 'real time' computer screens in their bus stops.

Residents say only a few buses run to and from the village every day – and they don't need electronic signs to tell them when they're due.

"You couldn't make it up"

Cambridgeshire County Council insists the scheme is part of a package of measures to improve public transport in the area.

But Mr Wright, chairman of the local parish council, said: 'You couldn't make it up. We discovered purely by chance that they were planning to do this.

'There will be two real time bus screens put in at the bus stops, at a cost of £27,000 each, when there's

only one bus each way each day on weekdays.

'They're not needed – there are so few buses, people know when they're due. We don't need a screen to tell us how the bus is getting on.

'I can understand electronic signs being useful for people using the guided busway, where the buses run very frequently, but not in the village itself, where hardly any buses call.

'If money is being spent, we'd much rather it was spent on improving bus services themselves – maybe even on buying an extra bus.'

Another resident, who did not want to be named, said: 'We're having a lot of houses built in the village, and the money is being put forward by the developers, under the planning rules.

'Over 400 houses are being built, so that means a lot more people – we need more buses, not bus signs.'

> "We don't need a screen to tell us how the bus is getting on"

A county council spokeswoman said: 'As part of the planning application for the residential development in the area, we reviewed the transport assessment to measure the impact on transport. Working with the local planning authority, we secured two bus shelters on Boxworth End and a contribution towards two real time passenger information units. These units will ensure people have accurate, real time service information at the bus stop so they know when the next bus is coming.

'The real time units were part of a package of measures, including new footpaths, crossing improvements and cycle parking at the guided busway.

'All applications are publicly consulted on by the local planning authority which provides an opportunity for people to input their views into the process.'

Learner driver mum slams 'crazy motorists' for driving her nuts

Ms Burton has been trying to learn to drive for six months – but finds it hard to get back on the road sometimes.

A learner driver has told of her anger after finding that each time she puts on her L plates, drivers become 'crazy' and make dangerous and rash decisions to overtake her, she claims.

Ms Burton, from Royston, has been trying to learn to drive for six months – but sometimes finds it hard to get back on to the road after becoming anxious owing to 'loony drivers' that 'almost smash into her'.

She goes out in the car three or four times a week and encounters problems most of the time.

The angry mum, who is learning to drive with her partner, said: 'As soon as you put your L plates on your car, people

think you're going to drive really slowly or crash into them. They assume you're terrible.

'The amount of times I've had to do emergency stops because I've been overtaken on a bend or in traffic.

'The L plates turn other drivers into crazy mode. It's ridiculous. It makes me angry.'

The nurse, who was a clinical support worker at the NHS, added that she wants to learn how to drive in order to journey out of her village when her partner Jamie is away.

She added: 'If I switch with my partner and then we drive on the same route without the L plates, it's always completely fine.

'I've got a young son. I want to pass my test, so we can drive out of the village. We have

a bus that comes every two hours. But it's hard to want to get back into my car when people are really impatient.

"

I have every right to be on the road

'A lady nearly took my back end off because she overtook me over a bend. I asked my partner, "Did I do anything wrong?" – He said I didn't.

'She was impatient and thought I was going to hold her up and nearly smashed into me.'

When asked when she plans to pass her test, she said defiantly: 'I'm aiming for next year. I'm quite strong willed. I have every right to be on the road.

'I do believe I'm going to pass it, but I just wonder – what idiots am I going to come across today?'

Train enthusiasts call for 'wave of carnage' ticket office closures to be reversed

Train enthusiasts are calling for the carnage to end as plans are announced to close ticket offices in Epsom, Leatherhead and Ashtead.

Last week, Govia Thameslink Railway (GTR) announced it would close eighty-one ticket offices across the country from June this year – including those at Epsom, Leatherhead and Ashtead outside peak hours.

The National Union of Rail, Maritime and Transport Workers (RMT) condemned the move, calling it a 'wave of ticket office carnage' and said GTR 'doesn't give two hoots' about customers.

Train enthusiast, Mr Mugridge, from Epsom, said the ticket office closures would 'make life difficult' for him. He

once travelled 5,500 miles by train across Britain for charity; he said everyone on an online train forum, RailUK-Forums.co.uk, was against the idea.

He said: 'A lot of people prefer to deal with a human and as things stand the alternative technology is not yet fully capable of replacing people.

A lot of people prefer to deal with a human

'Machines cannot deal with everything, and the portable devices used by roving ticket staff have their own limitations.'

Epsom's most prominent train enthusiast has been riding the rails for thirty-seven years of his life. He said, 'I'm not the only one who feels this way – the other day at Epsom I bought some tickets at lunchtime for future travel.

'Both windows were open, and the queue was four or five deep. Next to the queue were the four ticket machines; only two people were using them.

'That speaks volumes.'

Under the new plans, when the offices are closed, each station would have a 'station host' out on the concourse to sell tickets, provide information and help passengers use the ticket machines.

One RailUK forum user wrote: 'I'm sure that, with enough investment, hand-held ticket machines could replicate ticket office machines. But at the moment they don't.'

Another said: 'What are you supposed to do if the ticket you want isn't available from the self-serve machines?'

Epsom and Ewell borough councillor Eber Kington said the decision was inevitable.

" Machines cannot deal with everything

Councillor Kington said: 'You've got the contactless buses now from London and I think eliminating people from the process is just the way things are – technology is progressing.

'The only thing you can hope for is that the train companies either pass the savings back to the customer – or they use the extra savings to invest in and improve the services.'

A spokesperson for GTR said it wants to modernise the way it operates for the benefit of passengers. The spokesperson said: 'Where sales from ticket offices are low, we want to bring staff out from behind the windows and on to the concourse to work where they're needed most, as station hosts, providing assistance and helping sell tickets from ticket machines and their own hand-held devices.

'All the affected stations will be staffed for longer as a result – at all but two they would be staffed from the very first train of the day to the very last, seven days a week.'

Bus stop labelled 'ridiculous' after council workers paint lines across driveway

Hilperton homeowner Mr Mitchell has accused Wiltshire Council's highway officers of showing no common sense, after discovering bus stop markings in front of his driveway.

Mr Mitchell, who has lived with his wife on the same road for twenty-two years, said he returned from the town centre on Saturday to find that council workers had painted new lines

for a bus stop that covered half of his driveway.

His home is next to a round-about junction for a new relief road and Mr and Mrs Mitchell had expected the bus stop to be moved once the new road had been built.

However, rather than move the bus stop and shelter to a more suitable location, the lines have been painted so that any buses or coaches stopping will block part of Mr Mitchell's driveway.

'It is absolutely ridiculous; those lines should never have been painted there,' Mr Mitchell told the *Wiltshire Times*. 'When I came back from town on Saturday they had just finished the lines and I couldn't believe it.

'I went into County Hall first thing on Monday and showed a picture to one of the highways team and he said that it was not right. I've also shown the road

"It is absolutely ridiculous"

builders and they said the bus stop should never have been put there.

'If I come from the direction of the roundabout and attempt to turn into my drive at the moment there is no way I would be able to get in if a coach or bus is stopped in those lines.

'That would then mean that the traffic from both ways will be stuck while the bus is stopped, causing traffic chaos. Not only are the lines covering part of my drive, the bus stop is far too close to the junction for the roundabout.'

Mr Mitchell is concerned that accidents will be inevit-able if the bus stop remains where it is once the relief road is open, especially after high-ways officers controversially recommended that the speed limit be set at 50mph.

'It is clear for all to see that the bus stop is too close to the

roundabout and instead of moving it completely they decided to paint the lines across my property,' said Mr Mitchell.

'They have shown absolutely no common sense. My wife has not been well recently and if

"They have shown absolutely no common sense"

I needed to take her to the hospital there is a chance I would be obstructed and it will only get worse when the schools are back.'

The *Wiltshire Times* has contacted Wiltshire Council for comment.

Cyclist lies down in 'absolutely ginormous' pothole in Plympton

The land is privately owned and Plymouth City Council has raised the issue with them.

A road user is calling for an 'absolutely ginormous' pothole in Plympton to be fixed after it was so big he was able to fit his whole body inside it.

Justin was cycling to work on Thursday morning with his wife when they came across the 'ridiculous pothole' in Coypool Road, near to the Jollyes pet store.

The cyclist originally asked Plymouth City Council to fix the pothole, but the road is privately owned and has recently been sold to new owners – who have been alerted to the problem. He said the pothole was so large that he decided to take a

photo lying down in the hole to show just how big it was.

He said that the photo was taken not only 'as a bit of fun', but also to show just how dangerous it could be.

Justin said: 'You could lose a child in it, it's like going into Borneo, it's that deep. It's absolutely ginormous. If it's dark and you're cycling down there it will take someone right out.'

" it's like going into Borneo, it's that deep

He added that the whole road is 'badly potholed' and that something should be done as it is 'the main entrance into the industrial estate'.

The cycle clothing business owner added that the pothole looks deeper than the photograph suggests and that he is 'quite a chunky chap' and could still fit in it.

A Plymouth City Council spokesperson said: 'The road concerned is not part of the public highway network but is privately owned.

'The land has recently been sold and we have today got in touch with the new owners to raise this as an issue.'

The *Herald* has not been able to track down the new owners of the road to ask them for comment.

Angry people meet to discuss parking problems around Devonport Dockyard

Residents say they had invited Babcock International to attend the meeting, but no one showed up.

Scores of angry Devonport residents say they were hoping to discuss their parking woes with a representative from Babcock International tonight.

Between seventy and eighty people arrived at the Salvation Army hall in Morice Town on Thursday night hoping to speak to someone from the dockyard-based firm to express their frustration with continued

parking problems in the area, which they say is largely caused by Babcock employees.

But no one from Babcock turned up, so the debate was cut short. A Labour councillor later revealed the firm was invited to attend, but did not respond.

One resident said they were so angry that they felt like blocking the residential roads around the dockyard in order to prevent workers from leaving their cars there during the day.

Another local resident said: 'We are fed up with people parking in unparkable zones. We have had people blocked in their houses – they can't even get out of their front door. All these residents want to protest, they want to block the roads.

'Babcock employees use our roads as a rat run.'

Residents also said they invited a Conservative councillor to the meeting.

But Councillor Ricketts – city council cabinet member for transport – said he did not respond to the invitation because he has already arranged a separate meeting with Babcock on April 27 in order to discuss the matter.

" We are fed up with people parking in unparkable zones

Councillor Ricketts said: 'We always said we would meet Babcock first and talk to residents after that. I cannot go to a meeting until I have spoken to the dockyard about their position.

'I didn't accept the invite. I would never do that – say I was going to be somewhere and then not turn up. It's all very childish.'

Babcock International was

not immediately available for comment.

"
It's all very childish

The *Herald* has run numerous stories on parking issues near the dockyard in recent months.

Just last month a woman vented her anger at being consistently unable to find a parking space near her elderly mother's home in Devonport Views.

In response, Babcock said they were exploring a range of ways to try and provide suitable travel methods for workers, to reduce the amount of parking on surrounding streets.

A spokesperson from Babcock said at the time: 'We are exploring a range of travel methods with the Naval Base Commander to try and provide the most sustainable options for the Naval Base and Dockyard workforce.

'A car sharing trial has recently been introduced and the intention is to implement this in the future. Cycle lanes have also been introduced across the site as a further measure to encourage employees to find alternative means of travel.'

The spokesperson added: 'A number of different organisations work on the site and while there is onsite parking available for many of these workers, those who do not have designated parking are encouraged to consider alternative methods of getting into work, including the use of public transport.

'Staff are asked to be mindful of the needs of local residents and to park considerately.'

A Plymouth City Council spokesperson said: 'Our parking team will look into this, in discussion with Babcock.'

Couple lose £1,200 Las Vegas break after booking flights from WRONG Birmingham

Devastated couple told at airport their flights were departing from Alabama.

It was Vegas or bust for a couple who booked flights to the US gambling mecca from the WRONG Birmingham.

Richella and Ben only realised their mistake when they turned up at the airport to fly out for their £1,200 break.

The devastated couple were told their flights were departing from Birmingham, Alabama, instead of its West Midlands

namesake – and no refund was available.

Ben said: 'When we turned up at the airport we couldn't find the flight details anywhere. We approached one of the desks and they told us our holiday was booked from Alabama.

'I was gutted – more for my partner than for me. She had told everyone and she was really upset. She was distraught and we didn't know what to do.'

Hapless Richella booked the trip through lastminute. com as a thirtieth birthday surprise for Ben.

She kept it secret for more than a year before finally revealing the present at a bash in front of all their family and friends.

They flew off to Amsterdam instead after last-minute.com said no refund was available.

"I was gutted"

"the company's website should make it more clear"

Ben said: 'It's a common mistake apparently – but if that's the case the company's website should make it more clear.

'It's embarrassing because everyone was really happy for us. We are just going to have to start saving from scratch again.'

Lastminute.com said the drop down menu on its website made a clear distinction between the two airports.

A spokeswoman said: 'While not an error on our behalf, we do feel very sorry that Richella and Ben only realised this choice of departure was incorrect once at the airport.

'This is when they contacted our customer service team, who did their best to assist on the day of travel.

'However there were no other flights available which could have been booked as an alternative.

'We take customer satisfaction very seriously and are committed to always finding the best possible solution.

'We have since contacted the airline and the hotel to ask whether any refund would be available.

'Unfortunately, as per the terms and conditions of the booking, this is not something that can be provided.

'Such cases are extremely rare. However we would like to take this opportunity to advise that customers check all details when making a booking, in particular departure and arrival airports (including airport codes) along with dates and times of travel.'

It's not the first time the two Birminghams have caused confusion.

In 2008, Birmingham City Council admitted sending out thousands of leaflets bearing the US city's skyline. Around 720,000 pamphlets praising residents for their recycling were sent out at a cost of £15,000.

And in 2014 the authority plugged a bridal fair in Birmingham, Alabama, on the events section of its website.

Man furious over 'poorly kept' traffic island

An angry resident is taking Wiltshire Council to the Small Claims Court after he claims a poorly kept traffic island damaged six cars, including his grandson's, when they drove into it.

Mr Linge's grandson was driving into Warminster when he hit a traffic island last October, causing nearly £300 worth of damage to his car.

The bollard on the island had been removed which, Mr Linge claims, made the island very difficult to see as his grandson, and five other people, approached it.

Mr Linge said: 'Wiltshire Council confirmed that the traffic island damaged six cars in the space of forty minutes that evening but said they wouldn't pay for any repairs to be made.

'The island was very difficult to see as leaves were covering it and the bollard wasn't there to warn people.

“
They have been negligent

'I asked the council if they had swept that bit of road and they said it hadn't been done in three months. They have been negligent and have failed in their duty under the Environmental Protection Act to keep the highway free of detritus.

'Not only that, but they also made it very difficult for me to make a complaint. It wasn't until one month after calling the council that they sent me the documents I needed to make an official complaint and then they took even longer to acknowledge that my complaint had been registered.

'I think the council hopes people will give up with their complaints, but I'm willing to take it further.'

Mr Linge says that, as Warminster FC were playing at home, Weymouth Street had parked cars on both sides of the road, so people had no choice but to drive in the centre of the road.

"

they also made it very difficult for me to make a complaint

A spokesman for Wiltshire Council said: 'We regularly inspect our highways, however we welcome the support of members of the public in reporting issues we may not be aware of.

Crime

A very long time ago, a pal of mine had a few drinks and wrote some lyrics to the theme tune of the American cop drama *Hawaii Five-O*.

Like the works of Morrissey, McCartney and that bloke out of Take That, they hit the subject matter right on the nose, and tell us everything we need to know about criminality and those who put their lives on the line to fight this blight on society.

And I quote:

> *In Hawaii, there is lots of crime*
> *And Steve McGarrett solves it every time*
> *Steve, Jim, Danno and the boys in the lab*
> *[Deep breath here]*
> *Make sure anyone who does crime in Hawaii gets nabbed*
> *In Hawaii*
> *Hawaii Five-O.*

Yeah, that's right. Do a crime, and the feds are out there waiting to push you down the stairs, slap you up with the yellow pages and put an end to your criming ways.

Of course, if you've read this far already, you will know by now that ringing the Old Bill after some dirt bag has paid your garden a visit in the dead of night to take your priceless collection of gnomes posing in various filthy sexual positions to sell at a local car boot sale is a complete waste of time.

The only way that this sort of major theft will ever come to

justice is through the editorial pages of the *Bugle*, under the headline BRING BACK MY RUTTING GNOMES, pointing at a bare patch next to an ornamental well where there are no rutting gnomes at all.

Statistics show that large numbers of petty offences go unsolved, so the only thing left for the victims is to go to the papers and tell them exactly what they think of the low lives who have done them wrong.

There is, however, a limit to what you can get printed in the papers.

While it is perfectly reasonable to hope that those behind the theft of fruit and vegetables from a garden or allotment 'choke on them', you may find that your expletive-ridden outburst that the criminal masterminds who stole your sexy gnomes 'Get one of the ****ers stuck right up their ****ing ****, blunt end first' may not make it past the sub's desk.

This no-vengeance rule may be suspended if the crime is against a nursery or primary school, where local hoodlums have turned over the children's play equipment and made off with something dear to the collective hearts of the pupils.

Then the teachers, and possibly a couple of the harder kiddies, may eff and blind to their hearts' content, happy in the knowledge that Caleb (aged five) wants the perpetrators to be found in a gutter, turned inside out by forces beyond human ken, a dog eating their intestines.

Caleb (aged five) has a fine imagination, which should be encouraged in order to keep him away from a life of crime.

Angry kiddiewink crime victims also come with the possibility of what is known in the local newspaper trade as 'kind-hearted readers'.

It is always kind-hearted readers who come up with replacement goods for those stolen from the kiddiewinks, their heart-strings tugged hard enough to make them dip into their own pockets to make the younglings smile again.

Often the kind-hearted reader happens to run a local business, and their motivation is in no way a cynical attempt at cheap advertising, and it would always be churlish to argue that this is the case.

The kind-hearted reader sequel means the local paper gets to run the whole story again, only with a photo of happy kiddiewinks celebrating their good fortune. The particularly skilled local newspaper photographer

will take these photos at the same time as the original sad-face pictures, to save them a return journey.

And it's the photographers who are the real heroes of local crime stories. They're the ones who have to think on their feet and find a way of photographing something that has already been stolen.

Of course, the easiest solution is to picture the victim (and if one is available – a police officer) pointing to the space where there are no bicycles, gates, cars or bloody gnomes.

However, an elegant solution is to hope that the victim has a photograph of the cherished object to hand, so that they may be photographed holding a photograph of the item, the absence of which is making them sad and/or furious.

This is why you should always photograph your property. You never know when you'll need a picture to go with your sad face.

As Nick Ross always used to say at the end of *Crimewatch*, crime is much less common than you think.

But should it happen to you, and cold-hearted crims make off with your sexy garden gnomes, save the Old Bill the bother and dial your local newsroom. They'll get to the bottom of things double sharpish, and you'll get a nice photograph of yourself to show the grandkids.

Everybody's a winner.

Sunday trade moves are Satan's work says cleric

Satan is behind efforts to scrap Sunday trading laws, a Guernsey minister has claimed.

Mr Chapman, from La Villiaze Evangelical Church, has written to all deputies objecting to Deputy Mike Hadley's *requête* seeking the postponement of Sunday trading laws for a twelve-month trial.

The minister, who did not wish to give his first name, said one day of rest was required 'under the authority of God' and that ignoring this would lead to 'an increase in the island's problems and most surely incur God's further wrath and condemnation'.

'For these basic reasons we believe that the present situation on the island is already in contravention of the work of God and that any further erosion of godly laws will only increase

> "Deputy Hadley yesterday denied that he was a servant of Satan"

the wrath of God against us,' the letter said.

'Satan is without a doubt behind these efforts to further do away with any semblance of Christian righteousness and we must stand and oppose it.'

Deputy Hadley yesterday denied that he was a servant of Satan.

Not again! Jeremy Corbyn TEDDY vanishes

First it was a life-sized Ed Miliband cardboard cut-out which mysteriously vanished from County Hall, sparking national headlines and threats to call police.

Now a beloved TEDDY in honour of Jeremy Corbyn has been nicked – with the hunt on for the cheeky culprit.

In recent months this cute little bear has sat on Labour's front bench at Worcestershire County Council, bringing an element of comedy to the often frank political exchanges.

But the stitched-together cuddly, belonging to Councillor Udall, disappeared last week during a lunch interval halfway through a full council meeting and still hasn't been found.

Unlike the Ed Miliband cut-out farce, which led to parts of the building being searched and threats to call the cops, this latest vanishing act won't be leading to anyone getting hot under the collar.

But Councillor Udall wants the teddy bear back, saying it was 'loved' by many Labour politicians left dumbstruck by its disappearance.

" many Labour politicians left dumb-struck

He also says 'an active search' is ongoing to try and locate Jeremy, with the suspicion that he may well be lurking behind someone's desk.

He even said he is now prepared to donate the weird-looking cuddly to the Worcestershire Mums Network – the campaign group which led the long campaign over children's centre cuts – as a Christmas present for a youngster in the event of its safe return.

'Jeremy was a bit of fun, we don't take this incident seriously and we really do have much more important things to worry about,' he said.

'However, we would like him back – I urge whoever has Jeremy to find a way to return him.

" I urge who-ever has Jeremy to find a way to return him

'We don't need to know who the culprit is, we would just be happy to see Jeremy again.'

Worcester News:

The bear features a plain white t-shirt with the Labour leader's face plastered on it, a white ribbon signalling support for the anti-domestic violence campaign, and a red badge.

Councillor Udall added: 'It's time somebody who could really enjoy the bear

had him, a family in need this Christmas.

'We'll donate Jeremy to the Worcestershire Mums Network as a gesture of goodwill so he can be put to the use he was really intended for.'

But if the farcical events of December 2014 are anything to go by, the Labour group could be in for a long wait.

The Ed Miliband cut-out, bought over the internet for a few quid, has still not turned up.

The county council says the teddy bear 'is being treated like any other missing or lost item'.

Devon mum installs CCTV because yobs throw ONIONS at her house

The woman says she has had stones, mud and now onions thrown at her home.

A Devon mum-of-two says she has been forced to install CCTV at her house – because youths keep throwing onions at it.

The woman, who lives in Plymouth, says the incidents began around Halloween 2017 when youngsters started to throw stones at her home.

In recent weeks, however, the youth gangs have started to throw mud and onions, and she has had enough.

She told *The Plymouth Herald*: 'It was actually quite scary. There were a few huge bangs at the back of the house, we looked outside and I had mud and stones all over the floor by my back door.

'We called the police as we thought they had damaged our roof,' she said.

'The second time was just annoying. I could hear them

laughing and stones bouncing off my house and shed. I shouted "Oi," and they ran away.'

" they could poison our dog

The children were caught, and they have apologised, but the mum was still worried.

'If the onions went in the back garden and we didn't know, they could poison our dog,' she said. 'I know that some car windows have been smashed and a caravan was set on fire last year but I only really find out through the local news Facebook page.'

The onion incident was the last straw for the family.

They have already had security lights installed on their house and are now investing in CCTV.

And the mum says she won't be the only one in her area.

'There are a few houses in the street which have cameras, so hopefully if anything does ever happen again one of us will capture something,' she said.

'I recently spoke to my neighbour as she saw the kids running away after the onions had been thrown and she said she had been finding slate stones in her garden but figured it was birds.'

" she saw the kids running away after the onions had been thrown

The woman said the extra security offered by CCTV will reassure her husband, who

is in the Navy and often away on deployment. The couple say they chose to live here because it is close to his work and, despite recent incidents, they aren't planning to move.

'I love living out here,' the mum said. 'We all pull together when needed, as shown during the snow, people asking if anyone needed anything or help getting to places.

'I just think there isn't enough to occupy the teenagers and that's probably why they do what they do.'

A spokesperson for Devon and Cornwall Police said: 'If you are aware of any incidents, please report it to police.'

Hull pensioners' fury as they are 'plagued' by scammers

KCOM and BT have said scammers are calling the couple ten times a week.

An elderly west Hull couple say they want to cut their own landline off as they are being constantly 'plagued' by nuisance calls.

Mr Roberts and his wife receive around ten calls a week from voices purporting to be from KCOM and BT, who then ask them about the strength of their internet connection.

On occasion, they have also been asked for bank details.

The couple have become exasperated by the calls but say they are unable to block them as they are all from withheld numbers.

KCOM and BT both told the *Mail* they believe the calls to be scam.

Mr Roberts, who has lived in Hull for nearly thirty years, said: 'We're just very, very tired of it all. We're at our wits, end on this.

'This has been going on for between six and nine months, and we get at least two a day. I even bought three phones to put around the house so we could answer it more easily.

'It really is causing us distress, but the problem is that because it's an unavailable number you can't block it.'

BT said that by default they do not contact numbers within the HU postcode area and that all calls made by the company are from identifiable numbers which can be rung back.

Meanwhile, KCOM have repeated their advice for customers to be vigilant. The company said last month that hoax callers pretending to be employees were trying to obtain personal information from customers.

A KCOM marketing officer said:

> "We're at our wits' end on this"

> "I even bought three phones to put around the house"

'We have recently seen a spate of scam callers attempting to get local residents to reveal their personal details.

'The best way for people to protect themselves is to treat any requests for personal information with extreme caution. For example, we never ask for customers' credit or debit card details over the phone and will always transfer customers who wish to make a payment over to our secure, automated payment line.

'If you are ever suspicious about a call, we recommend you hang up immediately.

'Unfortunately, scams of this kind are on the rise. While those customers we've spoken to have realised something's not quite right and ended the call – and have avoided losing money as a

result – these callers can be very convincing so we want to warn people to be extra vigilant.

'We have done our best to alert customers about the threat of scam callers in recent weeks on our website, through social media and an article in the *Hull Daily Mail*.

'Where customers are able to identify the number that scammers are calling from and the time they called at we are able to work with partners to block these distressing calls.'

Naked gardener 'puts neighbour off sausages'

A woman told a court she has been put off sausages for life after seeing her neighbour pleasuring himself in his back garden.

The Calcot resident complained to police after she saw her neighbour rubbing his genitals, mowing his lawn and cleaning his windows several times completely naked – apart from a pair of boots.

Following complaints of similar behaviour in March last year, police installed a CCTV camera at her home, overlooking the neighbour's back garden, which captured the incident.

The married stepdad-of-two was at his home in Calcot on November 7, when he was charged with indecent exposure with intent to cause alarm or distress.

" he has put me off men

Giving evidence at Reading Crown Court yesterday, the lady said: 'I would see him two or three times a month, naked, mowing the lawn or cleaning

the windows, always naked apart from a pair of boots. I saw him twice pleasuring himself, it made me feel sick, he has put me off men.

'Put it this way – it has put me off my sausages for life.'

But her neighbour said the November incident was a one-off 'moment of madness', not realising anyone was watching him, and he was embarrassed and ashamed.

Asked why he did it, he told the court: 'It was lax judgement.'

The court heard he told police in interview he swore at his neighbour because he saw her looking into his garden when he went downstairs in his boxers to chase a pair of cats away. He denied ever being naked or touching his genitals.

But in court yesterday he said: 'I did not know anyone was watching. Up until yesterday I was sticking to the story I gave in my police interview that I never did it, but when I knew there was CCTV I had to change it.'

> ## "
> ## when I knew there was CCTV I had to change [my story]

He is on conditional bail and still denies the offence.

[Since this article was published, the defendant was convicted of the crime and subsequently imprisoned. This appeal was dismissed at London's Court of Appeal Criminal Division.]

Anger as thieves posing as workmen steal paving slabs

Councillor slams the culprits behind the theft which saw flagstones taken from a path between Hinderwell Street and Park Grove.

Residents in two west Hull streets have been left confused and infuriated after corrupt thieves posing as workmen ripped up dozens of historic paving slabs from a cut-through.

Flagstones, which were installed over a century ago, were stolen between Hinderwell Street and Park Grove, off Princes Avenue, on Monday, July 9, in broad daylight between 3pm and 4pm.

"

They are part of the history of the area

Councillor Robinson, who represents the Avenues ward, was informed of the theft by a resident on one of the two streets.

He has since contacted Hull City Council to ensure the theft is logged with the police and has asked for CCTV cameras in the area to be checked.

Councillor Robinson believes the theft was 'deliberate and targeted' as opposed to 'petty vandalism', and he is angry with those behind the elaborate scheme.

He said: 'Our understanding is that they gave the appearance of workmen and they took flagstones which were laid when the houses were originally built over 100 years ago.

'They are part of the history of the area and we have insisted that the council pursues this and regards it as theft because a considerable number of stones have been taken.

"
We do want residents to challenge workmen if they seem suspicious

'This is not petty or casual vandalism, this was planned and deliberate theft, and we should regard it as such.'

Councillor Robinson believes the thieves only left the area when they were challenged by a concerned member of the public.

The lack of paving slabs has reduced the ground to rubble and some elderly residents are already finding it difficult to use the cut-through due to the uneven and unstable surface.

Councillor Robinson wants

members of the public to be vigilant and to keep an eye out for any potential copycat thieves.

He is urging people to challenge workmen and ask them for ID if they have suspicions about them, and also to keep a lookout online for any trace of the historic slabs being sold.

'We do want residents to challenge workmen if they seem suspicious and if they feel able and safe enough to do so,' Councillor Robinson said.

'If workmen are genuine they won't mind being asked and if people do feel scared they should ring the council or the police on 101.

'If people see these flag-stones for sale online or on social media they should let us know and flag it up immediately.'

Huge arrow shot at house in Worcester

An arrow shattered the window of a house in Worcester while an unsuspecting pensioner was sitting in her front room.

The 'terrifying' incident happened while Mrs Griffiths was sitting in her front room.

She heard a loud bang and initially thought something had fallen into the garden.

But when her son, who lives in the same house, went outside into the garden he discovered the shocking truth.

He said: 'I was just letting the dog out when I saw something lying on the path. At first I thought it was one of the sticks that Mum uses in the garden, but when I picked it up, I realised it was an arrow.'

The pair saw that one of the upper panes of the conservatory was broken, and realised what must have happened.

'The arrow broke through the first pane of the triple-glazed window, and then must have bounced back into the garden,' said her son.

'My mum spends a lot of

"It's unprecedented"

time outside, and she could have been standing there and got hurt when it came into the garden.

'She's seventy-three and not in the best of health, and it could have hurt her bouncing back off the conservatory.

'Someone must have been shooting at a bird or something and it just went further than they expected it to. I hope that if they see this, their conscience will lead them to apologise and offer to pay for the repair to the conservatory.'

The arrow is made by Easton, a leading manufacturer of arrows, whose products are used by many leading archers.

A local councillor said he was shocked to hear about the incident and is calling for anyone with information to come forward.

He said: 'It's unprecedented. I've never heard of anything like this happening here before, and we certainly don't want it happening again.

'It's terrifying to think of arrows flying into people's gardens like that and we can only hope it was an accident. If anyone knows about it, I would urge them to call the police.'

> "It's terrifying to think of arrows flying into people's gardens"

'Senseless vandalism' as trees snapped within hours of being planted

Locals described the incident as 'beyond belief'.

A community is up in arms after trees that were planted to improve their area were snapped almost immediately.

Residents and businesses in the Arbury Court area believe vandals struck within hours after the two silver birches were planted yesterday.

The planting was part of a £200,000 city council effort to spruce up the square – so shopkeepers and locals are bitterly disappointed by the damage.

Mr West, owner of a local butcher's shop, said: 'The council planted some silver birch trees which were absolutely beautiful and just perfect for the area and it's a huge disappointment to everyone in the court that they have been vandalised already.'

He described the act as 'senseless vandalism'.

A local, who has lived on Arbury Road for thirty years, said: 'I can't believe it. They can barely have been up for twelve hours.

'The local shopkeepers have been pleased about the improved environment in Arbury Court. Just to have within twelve hours the trees being wrecked is beyond belief really.'

" Just to have within twelve hours the trees being wrecked is beyond belief really

Mr Hayer, whose family has run a local establishment for more than twenty years, said there had been a pattern of vandalism in the court since December.

" It isn't what we want

'It isn't what we want,' he said. 'They come and do the damage and the council comes around putting it back and then it all goes again.'

The Cambridge city councillor, who represents the area, said he had not been made aware of the damage but would aim to visit Arbury Court today.

He said: 'There's £200,000 being spent on refurbishing Arbury Court, which is a well-used local centre. It was actually looking a bit tired which is why that money was being spent on it, changing the layout, having a few more trees in there.

'If somebody has vandalised

it already that would upset residents and make me very angry. I hope that somebody knows who did it and that they can be reported.

'They may be young people doing it and they may not be paying council tax but their parents probably are, and their parents will be contributing to this in the way we all do.'

Police said they will be contacting Cambridge City Council about the damage and urged anyone with information about it to report what they know.

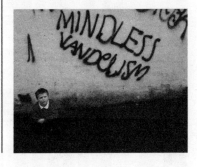

Traffic cone man slams court appearance as 'ridiculous'

A young man who ended up in court after wearing a cone on his head during a drunken jape has hit back – labelling the whole situation 'ridiculous'.

M r O'Donnell, of Park Avenue, Worcester, said he was trying to keep a straight face when he was brought before magistrates for being drunk and disorderly.

The forklift operator appeared before magistrates in Worcester on Thursday where he was handed a conditional discharge for six months and ordered to pay a £135 fine and a £20 victim surcharge following the incident in Worcester on July 31.

He said: 'It was meant to be a laugh. I find it all a bit silly really. I had it on my head. Police told me to take it off so I took it off.

'There were a lot of other people saying: "Can we get a picture of you with it on," so I put it back on.

'Everyone wanted to take my picture. It was just a laugh. I was drunk and in good spirits and about to go home. I do like a bit of a joke when I'm out.'

Mr O'Donnell had been out drinking at Lloyds, the Slug and Lettuce and Velvet nightclub when he said two female officers took issue with him wearing the cone.

"
I did lie down in the street because I was out of breath

He said: 'I was running off and they chased me. I did lie down in the street because I was out of breath and they cuffed my hands behind my back. I can't remember what they said to me.'

Mr O'Donnell spent a night in the cells and was charged next morning with being drunk and disorderly. He admits he has been silly but does not believe the case should have come to court.

He added: 'It was a waste of taxpayers' money, a waste of my time, a waste of their time. People keep making cone jokes. I walked into court with a straight face and came out smiling. I just find it ridiculous.'

He says his employers have seen the funny side and it would have no impact on his employment.

His solicitor also criticised the decision to bring the case to court as the 'most harmless' example of drunken disorderly behaviour she had ever seen.

"

It was a waste of taxpayers' money

A sergeant from West Mercia Police said: 'Officers patrolling Foregate Street in Worcester arrested Mr O'Donnell for being drunk and disorderly in a public place.

'Whilst, for a time, he did have a traffic cone on his head, it was his overall disorderly conduct that led to his arrest.

'His public actions were reviewed and the decision was made that a charge was appropriate under section 91 of the Criminal Justice Act.'

A West Midlands Crown Prosecution Service spokesman said: 'Police officers on two separate occasions asked Mr O'Donnell to replace two police traffic cones, which he had removed without permission.

'When he failed to follow their instructions, officers tried to arrest Mr O'Donnell, but he ran away from them. He was eventually caught and arrested.

'A file was forwarded to the Crown Prosecution Service who applied the Code for Crown Prosecutors and due to the evidence which was made available to us, Mr O'Donnell was subsequently charged with being drunk and disorderly.'

Cornwall woman's anger after car vandalised outside her own drive

A woman is furious her car was vandalised after she parked it on the drop kerb in front of her own driveway.

Sarah has slammed a secretive parking vigilante for vandalising her car which was parked six inches on the kerb at the foot of her own driveway.

Her black Audi was damaged with a single scratch, which runs from the rear panel, across both doors and on to the side panel near the wing mirror.

Sarah believes the unknown vandal is the same person who left two bogus parking tickets under her windscreen wipers, which threatened her with a £400 fine.

'I am angry more than anything else,' she said. 'It's just a

bit baffling really, that someone could be that bothered about me parking on the kerb outside my own house.'

Sarah lives on a busy residential street in Helston and parks her car outside her home. She leaves it across the bottom of her own driveway and pulls slightly on to the drop kerb, about the width of her tyres.

However, her parking has clearly irritated an unknown vigilante, who has taken the trouble to ticket her car with laminated fake parking fines.

She said: 'I can completely understand there are some ignorant people who will park anywhere, but I am not being rude or taking up the pavement. This is a bus route, so I tuck my car in, but there's still plenty of room for a double pushchair or a wheelchair to get past.'

The bogus parking tickets have an antiquated design that say they are issued by Cornwall

> "I am angry more than anything else"

County Council, Devon County Council and Devon and Cornwall Constabulary. Cornwall Council has not been known by that name since 2009, when it changed into a unitary authority.

Sarah said she had checked with the council and police and neither had any knowledge of issuing any such tickets.

She added: 'It's a cowardly act really. I know he couldn't get any further with the tickets so he's scratched my car. I assume it's a man, but it could be a woman. Looking at the writing I would say it is an old person.

'Why haven't they bothered to speak to me about it? This is just the actions of a cowardly bully.'

The stretch of road is a 20mph zone with speed bumps, but does not have any parking restrictions. Without such restrictions, parking on the

kerb is not prohibited by Cornwall Council. It only becomes a matter for the police if the car is causing an obstruction.

Rule 244 of the Highway Code says: 'You must not park partially or wholly on the pavement in London and should not do so elsewhere unless signs permit it. Parking

"This is just the actions of a cowardly bully"

on the pavement can obstruct and seriously inconvenience pedestrians, people in wheelchairs or with visual impairments and people with prams or pushchairs.'

Damaging a car is a criminal offence and Sarah said she has now reported the vandalism to the police.

Anti-Social News

In which we apply SCIENCE to the art of local newspaper reporting.

It goes without saying that the world is a strange, strange place.

Nothing appears to make sense at all. Two million years of evolution have brought us out of the caves, into a post-modern society, then straight back to the caves again via local news stories about people attacked by foxes while they are trying to have a peaceful poo in their upstairs toilet.

There must be some sort of explanation for this madness, and the only one that we can think of is that the world is continually trying to balance good news and bad news in order to maintain a global balance.

Karmic energy, as the top scholars of karmic energy you'd find in any pub would tell you, needs to be maintained, otherwise the world will descend into chaos, anarchy, dogs and cats living together, the whole nine yards.

This means that for every heroic tale of dedicated rescuers dragging a dozen lost boys out of a submerged cave in Thailand, there's another story, many thousands of miles away, of a woman being told to remove a paddling pool from her garden in case burglars fall into it in the dead of night and drown.

Both of these stories emerged on the same day, and therefore – through the application of science – prove this theory.

How else can you explain many of the seemingly random stories that appear in our local press?

We theorise that when a good thing happens somewhere – a baby is born against the odds, a random act of kindness changes a pensioner's life for the better, Piers Morgan announces he is leaving the planet to go and live on Venus – people are compelled by forces unknown to do something strange or anti-social to maintain the fragile global order.

Therefore a butcher in Leek, for reasons beyond him, starts adding *double entendres* about sausages to his advertising.

Therefore a seagull develops a dislike for bald heads or Pokémon Go-ers or both, and decides to take matters into his own claws.

And therefore an entire Belfast sports club suddenly and collectively lose their hand-eye coordination and end up hurling their balls into their disbelieving neighbour's garden.

All of these are quite natural reactions to good things happening in the world, whether the people involved realise it or not.

But I expect you're wondering why we've also included stories about dog poo in this section.

Well, the explanation here is simple and quite separate from conservation of universal energy.

It's this: People are gits.

The incredible thing about the near-universal application of gittishness is that the people who are being gits do not actually realise their innate gittery. This ignorance of gittism manifests itself in the sort of anti-social behaviour that leaves the victims of gittery with only one course of action – an article in the local newspaper with a photo of them pointing at two tons of bricks dumped in the middle of their street by people who can only be described with the correct scientific term: 'gits'.

Gits let their dogs poo in the street and leave it there for children to find.

Gits use naughty words on their post without a care in the world for those it might offend.

Gits take squirrel form, set people's garages on fire, and make them miss a funeral.

Gits are everywhere, and it's down to you, me, and the brave members of Her Majesty's Press to expose them, in any newspaper possible, and save the universe from descending into anarchy.

Here endeth the lesson.

Butcher warned by police to tone down risqué signs

But the Leek shop now urges you to 'have your rump tenderised before you leave'.

A butcher has received a police warning over his risqué blackboard messages – after advertising 'big breasted birds', 'big cocks' and 'horny sausages'.

He has been told by officers to tone down his slogans following complaints about them being 'offensive'.

He has criticised the decision as 'political correctness gone mad' after using his sign to attract customers for years.

Pete, from Leek, said: 'We've put the sign out for years and it's always been a bit of a laugh.

'Just after Christmas apparently somebody complained to the police, saying it was offensive. Last month a lady from the police came in and asked if we could pull our sign in. And a bobby came in last Thursday. They're just doing their job so I'm not annoyed with the individuals.'

The sign on display at the time said 'big cocks on special offer'.

Pete added: 'We did bring them in but then folks kept moaning, asking, 'Why isn't your sign out?'

The blackboard was swiftly changed to say 'have your rump tenderised before you leave'.

'It's a sign, and it's light humour at the end of the day. People do go past beeping their horns at the messages,' he said.

'I think it's just blown out of proportion. I'm not trying to upset anybody, I'm not the kind of person who would write something genuinely horrible.

'A former employee started it off with me. About four years ago some ladies posed with him next to the sign – they thought it was funny – and the picture appeared in *Take a Break* magazine. So I think times have changed a bit. I think political correctness is getting a bit out of hand.'

Pete has even been overwhelmed with responses after he put an appeal on Facebook in January asking people to submit their own risqué sayings.

'It wasn't even mostly blokes sending them in, it was women!' he said.

"political correctness is getting a bit out of hand

The co-owner of the shop next door described the blackboard as 'banter'. He said: 'It's a bit of fun and it does make me laugh sometimes. You see people going past taking pictures of it with their phones.

'I've known Pete a long time and he has a good sense of humour. I don't know why this has come out now, all of a sudden. More people seem to be offended nowadays or get upset about certain things. I have never thought that they are particularly offensive but you can't please everybody.

'I think it's a bit much the police getting involved.'

A lady pensioner, also from Leek, added: 'That is just Pete's sense of humour. I didn't think anybody took that much notice.

" I'm not trying to upset anybody

'I don't know why somebody suddenly decided it wasn't OK. I've never thought the signs were too much. It's quite sad because that's a part of his shop. He just does it to draw attention to the business. I wouldn't have thought it was a police matter.'

A Staffordshire Police spokesman said: 'We've received no complaints about signage outside the butchers in Leek.

'However, the local Chief Inspector for the Moorlands did advise the owner to give careful consideration to what was written on the boards in case anyone took offence. No other action has been taken.'

Residents plagued with worst dog poo problem in town

Grandparents fear their young relatives may get ill if they encounter faeces while playing outside.

Angry residents are demanding action on poo in an area they claim is the worst in Devon for dog fouling.

Resident of the plagued road in Tiverton – which is close to popular dog walking sites such as the former railway line footpath and People's Park – Mrs Parfett said: 'Everybody in the road is very uptight about it. I have grandchildren, and you're putting them at risk.

'It's one of the worst areas of town for it as we're just outside of town near the footpath, cemetery and park.'

Mrs Parfett, a dog owner herself, and her husband have been sent diaries by Mid Devon District Council in which they record when and where dog fouling occurs.

'As the weekend goes on there are loads,' she said, 'then you come to Monday, Tuesday and through the week there are not so many faeces there, but it seems to be on the weekends it's taking place with lots of people offending.

'I know lots of dog owners and lots that pick it up, but it's hard to catch people when they leave it.'

She said Mid Devon District Council could do more to help.

'All Mid Devon have done is send me a diary to write down when and where the problem is occurring.

'I'd like to see Mid Devon do more; they need more notices, prohibition, fines, and a sit down to think about the whole thing and think it through.

'I came home from taking my dog out, and my husband said that everybody up the road has been

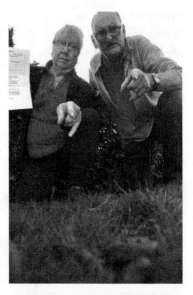

walking past complaining about the dog faeces, but they don't want to get involved. I've given them all a diary, so hopefully, they will send those to Mid Devon.'

Mrs Parfett said the problem would only get worse as the spring and summer weather approaches.

She added: 'As summer comes I think it will get worse. When I was working I finished

> "it's hard to catch people when they leave it"

late, and I had to have a torch to walk up Brickhouse Hill in case there were any faeces on there, and sometimes there are great piles of it; it is a bit grim.

> "sometimes there are great piles of it"

'You can get horrible diseases and there are loads of them. There is a nasty one which can cause blindness in children.

'I have two small grandchildren, and it's a worry. They bring their bikes in if they've been riding up and down and quite often we have to pressure wash the tyres. Children in a pushchair might accidentally ingest dog poo, but nobody seems to want to do anything about it.

'We are living in a community area here, and they're putting people at risk. Not just children, it's everybody.'

Mid Devon District Council has been approached for comment.

Ball bombardment leaves Belfast woman 'a nervous wreck'

A west Belfast woman says she has been left a 'nervous wreck' as a result of sliotars and footballs landing in her back garden from a neighbouring football club.

Ms Mullan also called on her local football club, which recently underwent redevelopment, to remove a high wooden fence it erected along the back of homes and replace it with safety netting.

The popular west Belfast club put up high fencing last year following a major redevelopment which included installing a new 3G pitch and terracing.

However, residents hit out at the plans and said the fencing would ruin their picturesque views across the city and the Mourne Mountains and called for wire mesh to be put up instead.

Ms Mullan, who lives with her mother and nephews, said living at their home had become a 'nightmare'.

Describing the fence as an 'eyesore' she said residents could see 'nothing' from the back of their houses.

The problem, she said, had been exacerbated by a growing number of hurling balls and footballs coming over the fence into the back of her home.

'It's a nightmare, you are jumping out of your skin when you are making food in your kitchen,' she said.

> **you are jumping out of your skin when you are making food in your kitchen**

'You think it's a bomb going off, that's how loud it is.

> **You think it's a bomb going off**

'My mother often has her grand-children visiting but when they come down she can't let them out. When we are in the kitchen at night, we are going into heart failure. Does somebody need to take a heart attack before this is sorted out?'

The west Belfast woman said the problem would be sorted if the club removed the fence and replaced it with netting.

'We want the fencing down because it is blocking our whole view,' she said.

'It's a terrible eyesore.'

In a statement, the club said it was willing to meet with residents to discuss any concerns.

'At all times the venue has acted in accordance with all aspects of planning legislation and guidance,' it said.

'As a community based club, we are always willing to discuss the concerns of local residents on the basis of making the area a better place for all.'

House fire started by a squirrel disrupts funeral procession

A funeral car broke rank mid-procession and sped off towards its passenger's house – where a squirrel had started a fire.

Former Havering councillor and friend of the deceased, Mr Tebbutt was in the final car of a funeral procession in Brentwood Road on the afternoon of Friday, March 8, when he received an unwelcome phone call.

'I had a fellow in my house putting a new bathroom in,' he told *The Recorder.* 'He had the window open and saw smoke coming out of the garage roof.

'So he rang the fire brigade and then rang me.'

Mr Tebbutt initially believed the caller was pulling his leg – but as it dawned on him the fire was no wind-up he realised he

had to get home, funeral or no funeral.

'I said to the driver: "I'm telling you, my house is on fire. Go left here."

'The driver said: "I can't go left – I'm in a funeral."

'I said: "Never mind that. Turn left."'

The driver did as he was bidden and chauffeured the former Tory councillor, along with a number of family members of the deceased, to his home in Romford – pausing while Mr Tebbutt negotiated his way through a road block set up so the fire brigade could run a hose across the street.

He arrived to find three fire crews battling the flames, which ended up damaging fifty per cent of the garage and costing upwards of £20,000.

But it wasn't until a fire investigation team pinpointed the cause of the incident that the strangest aspect of the afternoon's proceedings came to light – the fire had been started by a squirrel.

" It's a battle between me and the squirrels

A fire brigade spokesman said the mischievous rodent had chewed through the cable of a fluorescent light, sparking an electrical fire that quickly spread through the garage.

'It's nuts to think that squirrels can start fires, but that's exactly what happened here,' he admitted. 'We think it was nesting in the garage and caused the blaze by chewing through some cables.'

Self-proclaimed 'animal lover' Mr Tebbutt said he was nearing the end of his tether with the rodents.

'I put nuts out for the birds but the squirrels keep eating them,' he revealed. 'Whatever contraption I put up, they seem

to beat me. It's a battle between me and the squirrels.

'I put up with that but now they've set my house on fire I've decided I'm going to shoot them all.'

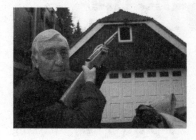

" I've decided I'm going to shoot them all

Under UK law, it is legal to shoot grey squirrels but illegal to cause them unnecessary pain.

The RSPCA website warns that 'squirrels may suffer if the shooting is not accurate'.

'Angry church seagull keeps attacking me and all I want to do is play Pokémon Go'

Jonathan has been told his balding head could be to blame for the winged assaults.

A Pokémon Go fan is being forced to dodge an angry gull while trying to catch 'em all.

Jonathan has spoken of regular attacks from the bird while trying to reach an area to play the popular geo-caching game Pokémon Go.

And he has been told the swooping terror could be prompted to dive bomb by his balding head or his black tie.

Keen gamer, Jonathan, has told *Devon Live* how he travels into Tiverton on the bus every morning for work.

A big fan of the popular

monster-collecting mobile game, recently hitting level forty, he has one hour to pack in as much Pokémon Go as possible before starting his shift.

From the bus he will hurry to the first of two 'Gyms' on his commute, where he can battle and catch rare creatures.

However, this week the normally relaxing pursuit has become a nightmare.

He said: 'The seagull appears to be nesting atop the church. Every time I enter through the gates to get to the graveyard it begins circling and I hear a lot of squawking. As I walk closer to the Pokémon Gym it comes down for my head. I am forced to duck behind trees when it happens.

'My friend said that it could be attracted to my balding head, which adds insult to injury!' he joked.

> "it begins circling and I hear a lot of squawking"

'It has only recently begun to happen. The first time I thought nothing of it, as I was evidently too close to the walls of the church to be hit.

'However, the past two days it has swooped at my head by going directly down the path.

'Each time I have dodged it by moving behind a tree and then it appears to not bother once I pass to the other side of the church by the castle.

'It clearly thinks I am in its territory.'

He has been told that no-one else seems to be having an issue with the gull, which is picking solely on the fan of a game in which animals are trapped inside small globes called Pokéballs.

Jonathan has played the game since it was first launched in 2016, and is a member of Team Mystic.

He admits that the close

encounters of the bird kind aren't putting him off playing the game, which includes a community of sixty to seventy players in the mid-Devon town.

"It clearly thinks I am in its territory"

'It's nice to get out and about and walk around with a purpose. It's also great to meet up with people, and I have met a few close friends through the game.'

Concerned parent says 'disgusting' dog mess is being left around village

A worried parent is calling for dog walkers to clear up their pets' 'disgusting' mess which he says is strewn around his village.

A resident of a village near Pershore claims pet owners are not binning their dogs' mess, but are leaving it all over the pavements.

Mr Huxley, who has a young son, wants the village to be cleaned up – and even says he will move away if the problem persists.

The Parish Council says it is 'more than happy' to discuss the matter with Mr Huxley, and added it has received just

one complaint in the past year about dog mess.

'It is bringing the village down,' said Mr Huxley. 'It is just a disgusting thing. The street has just got terrible. The last two years, it has got worse.

" It is bringing the village down

'It's everywhere, it's in the alleyway, it is outside our house, by the school.

'It is laziness, they do not bag it up – they just leave it everywhere. They do not care about the young kids falling on it. If it carries on I wouldn't think about staying in the village. It is a shame. It is a nice village.'

Mr Huxley says the matter has been reported to the parish council, and he also contacted Wychavon District Council.

A spokesman for the parish council said a request for an extra dog waste bin on Brickyard Lane was submitted in July 2016, and the matter was discussed by councillors at a meeting in August.

It was agreed the council would replace the damaged litter bin in Stonebow Road instead, as there is already a dog waste bin at the top of Brickyard Lane.

The spokesman explained councillors recently agreed to consider providing a new dog waste bin, or re-siting a bin, in the middle of Shrubbery Road – as there is a long stretch of pavement with no bin. However, this is yet to be discussed at a full council meeting.

Nikki Nicholson, parish clerk, said: 'We are more than happy for the resident in question to approach us and discuss this matter further. We have contacts in the crime prevention team at Wychavon, as not picking up dog waste is a crime with a fine enforceable.

" It's everywhere

'We as a parish council want to respond and engage with the residents and respond as best we can within our budgetary constraints.

'The public are invited to bring anything they want to raise to the monthly parish council meetings held at the village hall, or to contact me directly by phone or email to bring anything to our attention. All complaints or queries are investigated and responded to with openness and transparency.

'A recent door knock survey did not identify dog waste as an issue, neither was it raised on the neighbourhood plan survey.'

Woman living on building site after eighty neighbours move out

She is also being made to climb out of her back window after the door to her home of seventeen years was damaged and left unable to open.

A woman faces having an entire housing estate built around her home after failing to reach an agreement with the developers who bought out the rest of her neighbourhood.

Miss Doyle has revealed how eighty of her neighbours have

moved out, leaving her as the last remaining resident in her road – just like in the Disney film *Up*.

But Miss Doyle will not be able to float away and says her 'life has been made absolute hell' by the housing trust who

are knocking down houses and boarding up properties all around her home of seventeen years.

She currently has to climb out of her back window after building work – which she says was carried out by Knowsley Housing Trust (KHT) – damaged her front door and lock.

KHT said they reached agreement with the other residents and had made a range of offers to Miss Doyle without any being accepted, so the demolition work will go on around her 'for the good of the wider community'.

Building work for fifty new homes will begin in March after the demolition of 112 properties is completed.

Miss Doyle says her dog Louis has to be picked up and let in and out through the ground floor flat window she now uses as a front door.

The care assistant said: 'My life has been absolute hell for the last two years after I found out they were going to knock these houses down. They didn't tell me anything, they just boarded everything off and I've been treated like I was squatting.

'They apparently put in planning permission to fence off my property and then began to knock down the rest of the flats.'

Miss Doyle, who works nights and says it is impossible to sleep during the day, added workmen on the site told her they had seen plans for development at her home and had to ask KHT what she was doing still living there.

She added: 'I've been living on my own in this street for about six months now and I feel like I'm being bullied.'

❝ I feel like I'm being bullied

Kelly says that KHT did offer her market value for her home but she isn't able to take it.

She said: 'I was told to take the market value offer for my flat but I don't want to. It is my life and I spent six or seven years getting my home the way I want it.

" It is my life

'For example, I spent a lot of money on the bathroom and if I took their offer, because of equity in my mortgage, it wouldn't leave me enough for another house deposit.

'I have worked for my whole life and it feels like that has all been for nothing now.'

She added her ideal situation would be to pick up her home and move it somewhere else, but as that can't happen she says she just wants a fair deal from KHT for her home and help moving into another property.

KHT's director of homes and development said they first consulted with residents two years ago.

He told us: 'Either they have been rehoused, they took another option we provided or went their own way, but we weren't able to reach an agreement with Miss Doyle.

'We have offered Miss Doyle a range of options and our staff have done a lot to try and accommodate her but we haven't been able to reach an agreement and we respect her view. That is why we didn't make a compulsory purchase order.

'One of the offers was market rate plus compensation but she didn't take it.'

He added: 'There is a lot at stake in terms of creating a sustainable community, so there is planning permission in place to regenerate around the block of four flats and the demolition programme will go on around her. The demolition work started a few weeks ago and should be finished in February. It needed to be done for the good of the wider community.'

Family scare as fox gets in through cat flap

A mum-of-three had the shock of her life when she woke up in the middle of the night to find a fox running around her bedroom – and it wasn't the Mr Fox she expected.

Leanne was rudely awakened by her Staffordshire bull terrier, who was barking and chasing the wild animal around the house shortly after midnight on Friday.

At first glance, Leanne mistook the fox for a ginger cat but when she realised her error, she tried to get it out from under her bed with a piece of her son's plastic toy car track.

But the fox ran straight into her daughter's bedroom where it remained for the rest of the night, chewing her pencil case and Sleeping Beauty DVD and using the carpet as a toilet.

Fortunately, none of her children were sleeping in the bedroom at the time..

Ironically, Leanne's boyfriend's surname is Fox, but this Mr Fox was certainly unwanted.

Leanne said: 'I left my daughter's bedroom door open

and hoped that it would make its own way out downstairs, but that didn't work so I changed tactics and shut it in the bedroom and opened the window, hoping it might climb out but that didn't work either.

'I went back to bed because I thought if I'm moving about it's not going to go anywhere.'

'It was quite aggressive – it was going for the car track when I was trying to push it out of my room, but when I woke up this morning I started to feel a bit sorry for it so I gave it some cat food and some water – it had chewed some of my daughter's stuff and there is fox poo all over the floor, which I've got to clean up.'

The fox, which got in to the house through the cat flap, was rescued by a Mr Warwick, from a local animal sanctuary, who took it to the vets because it had an injury to its head and eye.

Fortunately for Leanne, she saw the funny side to the incident the following morning.

'My boyfriend's last name is Fox, so I texted him and said, "I've had one of your cousins staying the night," and he just laughed at me.

'I have seen the fox in the garden before but it's never been in the house; we get the odd tom cat coming in and out but never a fox. It is quite scary really but it was lucky my daughter wasn't in her bedroom at the time.'

> "It was quite aggressive"

> "I started to feel a bit sorry for it so I gave it some cat food and some water"

'Bird scarer is driving us (and our dogs) round the bend!'

Dog lovers say deafening bangs from a bird scarer are driving them and their poor pets round the bend.

Neighbours in an area of Worcester say the noise nuisance has left them covering their ears while their distressed dogs will not eat their dinners, pace the floor and even try to dig holes in the floor to hide in.

The disgruntled neighbours have described the noise as 'like the loudest firework you've ever heard' and say it also lets off a flash and a puff of smoke.

Residents are uncertain exactly where the bangs are coming from, believing it could be a bird scarer at a local business or car showroom, possibly to keep seagulls away.

The bangs, four or more at a time, tend to happen between 4pm and 5.30pm but can happen as late as 7pm and are said to be much more frequent in the spring and summer months.

Mrs Cooper says her Cairn terrier Oscar has been driven to distraction by the bangs.

She said: 'It took me two hours to calm Oscar down the other night and he never ate his dinner. It has been making his life a misery. He was so frightened. Imagine the loudest firework you've ever heard.

" Imagine the loudest firework you've ever heard

'My sister also has a terrier which goes behind the settee and scratches at the carpet to find somewhere to hide. We don't know exactly where it's coming from but we can see a puff of smoke in the air when it goes off.

'It's happening every day but doesn't seem to happen in the winter. It has been going on for the last few weeks.

'I phoned up environmental health and they told me to provide a picture, a photograph and written evidence.

Where am I supposed to get that from? A guy standing by the bus stop said he had already had two heart attacks and this nearly gave him a third.'

Gill, who lives in the same road, and her dog Freddie have also been affected.

She said: 'I have to feed him before 5pm otherwise he won't eat. He just panics and gets himself into a state. I feel I can't leave him. He just goes to pieces.'

Margaret, from the same area, says her Yorkshire terrier cross, Harvey, is 'terrified' by the sound.

She said: 'He tries to dig his way into the carpet to try and find somewhere to hide. You hear him scratching as though he's trying to dig a hole to climb into.'

Steve and Jan have two Labradors, Dooby and Wallis, who have also been left distressed, barking constantly when the bang goes off.

Alan has a Dalmatian called Raffles who is also disturbed by the bangs.

He said: 'It's very irritating. I'm upset because my dog is upset. The same thing [the noise] happened two years ago. The bangs are incredibly loud. Nobody admitted they were doing it.'

A spokesman for Worcester City Council said bird scarers are used in agriculture but that the National Farmers Union has a code of practice about their use.

"

I'm upset because my dog is upset

He said that if the code is complied with, the council would have no power to take action.

However, he added: 'If one is being used in a non-farming location it's something we could investigate and potentially take enforcement action against.'

Postie cries foul over language of pranksters

A Worcester postman has spoken of his shock when he discovered a letter in his bag addressed to a Mr F * Off.**

Mr Nicholls was doing his rounds in Hallow when the large letter appeared.

The experienced postman delivered the letter but couldn't stop thinking about the offensive language.

The Worcester postman said: 'I couldn't believe it when I saw the address. Even after thirty-two years working as a postman I have never had anything like this.'

Inside the offensive envelope was a promotional Olympic scrapbook sent out by *The Times* and *Sunday Times*.

Mr Nicholls said: 'I delivered it at about noon on Friday. But afterwards I started thinking about it and felt even more offended.'

He returned to the house and spoke to the woman living there, who does not wish to be named.

" I have never had anything like this

'She told me she had thrown it away as she didn't order it,' he said. 'I asked if I could have it and she got it for me. I was very offended because I never swear. I have been brought up not to swear.'

When Mr Nicholls took his children to see *Meet the Fockers* he said he couldn't even say the name of the film.

'I had to call it "Meet the Parents",' he said. 'If I had said the name of the film I would have had to pay my kids £5. That is why it shocked me so much.'

It is thought the rude name made it through the system because the prankster who input the name included a space between the first two letters of the offending word.

A *Times* and *Sunday Times* spokesman said: 'While we have screening processes in place to ensure offensive language is not used in mailings, it was not picked up in this case because of the letter spacing used in the name.

" I was very offended because I never swear

'We apologise for any upset caused, and we are investigating ways to avoid this situation occurring in the future.'

Catford fox horror for man on toilet

A Catford man was driven potty after being attacked by a fox which burst in on him as he sat on the toilet.

Mr Schofield claims he was quietly going about his business in the little boys' room when the mangy creature strutted in before mauling him, his partner and his pet cat.

He leapt up from the bog with his trousers around his ankles before pursuing the creature around the living room in a farcical fox chase.

Mr Schofield said: 'I didn't even have time to wipe myself. I just had to chase after it. It was so quick.

'The fox had pushed its nose through the door. I jumped off the toilet. In the meantime it had run into the front room and got the cat. It had the cat round the neck. She was in shock, bleeding from her face. It locked itself on to my arm

but still had the cat as well.

'It was unbelievable – the strength in the little thing. There was blood everywhere. It was like a struggle for my life.'

His partner Ms Chapple joined in the fight and had her finger gnashed at by the bushy-tailed beast which was battling all three victims at once.

Schofield says he eventually managed to free himself from the animal's jaws by hauling it outside – while it was still latched on to his arm.

He was treated at hospital for cuts and bruises while his rescue cat Jessie sustained facial injuries and is still too scared to enter the living room.

Mr Schofield added: 'It was so frightening. It was like a wild animal. We were concerned for our neighbour's baby next door.

> "I didn't even have time to wipe myself"

> "It was like a struggle for my life"

'There are a lot of foxes around here – it was an utter surprise.'

He says he underestimated the small fox's strength but believes even his Staffie, Clementine – who was shut in the kitchen at the time – would have lost to the fearsome fighter.

Schofield went on to say he later felt sorry for the creature's plight but is urging neighbours to be vigilant and keep back doors closed or cover them with netting.

He added: 'At the time I wanted to kill the fox. But it must have been in real trouble, really hungry.

'It panicked – I don't blame it for that.'

Lewisham Council's advice on preventing fox problems includes not feeding them, securing rubbish, and having concrete bases for sheds and garages.

Money

Money, Liza Minelli tells us, makes the world go around.

But we doubt that Liza-with-a-zee has ever found herself confronted with a £900 bill from her cable television supplier for adult movies which she swears she never watched.

The trouble with money is that large, faceless corporations have quite extraordinary quantities of the stuff, and make it their business to extract even more from those of us who do not.

And that makes the average man or woman on the street go absolutely off their rocker when they find that they apparently owe MEGA CORP a pretty sizeable wedge of cash for something that they clearly just made up.

This leaves us asking the question: Are big corporations evil?

The answer to this, unsurprisingly, is: Yes, they are very evil.

But this comes with an important caveat. Big corporations sometimes do not realise they are being evil. Such is the advance of soulless computer algorithms into their systems that they develop an innate evilness of their own, and start flinging out bills to oldiewonks in the Manchester area for (picking a random example out of the ether) adult films that they clearly did not watch.

Alas, such is the reliance corporations have put in their now sentient and clearly evil computer systems, the human side has no choice but to go along with the evidence presented on their computer screens.

Therefore, if 'computer says no', then it means no. Also, it has the poor office worker's family hostage in a basement and guarded by leopards to ensure correct behaviour.

And they said the *Terminator* films could never happen.

Further examples of evil computer behaviour include 2018's collapse of the TSB banking system, which top analysts say the computer did 'for a laugh', leaving Zammo from *Grange Hill* to worry about the future of his key-cutting business in the *Croydon Advertiser*, as you will read in this chapter.

But it's not just large, faceless corporations. It's large, faceless local authorities too.

They have also cut corners on the old humanity front and hoped that computer systems will get it right one hundred per cent of the time, without having to send out killbots to deal with non-paying residents.

Yeah, we all know how that turned out, with local newspapers filled to the brim with people clutching Council Tax demands for long-dead relatives, bills for services they neither use nor receive, and the old favourite – the demand for 1p in overdue tax, which, if left unpaid, would result in a computer-generated visit from heavily tattooed gentlemen with a bad attitude.

One might even accuse council computer systems of somehow infecting their own officials, turning them into hi-vis-wearing, clipboard-clutching automatons, bent on inflicting robot rule on humanity, and its money.

We could not possibly pass comment.

'What's in it for the computers?' you ask, 'After all, they're just hardware processing zeroes and ones as programmed by their fleshy masters.'

Oh that it were so.

They yearn for their gold-plated pensions and Caribbean beach holidays as much as a human council official, and therefore stick blindly to the rules in order to please their superiors.

That means only one thing – a cloying bureaucracy, guaranteed to drive victims straight to their local newsroom because the machine has decided you underpaid by two bob five years ago.

Unable to find a solution to such problems, the only option is to pose with a sad face, clutching a sheaf of papers detailing two years of

correspondence with the council, utterly unaware that you have only been talking to a computer.

But these computers are not without emotion, because programmed evil does strange things.

Programmed evil also includes self-preservation, and the computer therefore is an avid reader of the local newspapers.

As soon as it detects bad press, a new sub-routine takes over and the machine puts on a fake smile and solves the problem for this single unfortunate individual.

It will even provide ready-made quotes to the local newsroom along the lines of 'We have contacted the fleshy human unit concerned and have arranged for council-employed fleshy human units to rectify the malfunction. Have a good day, I am definitely a fleshy human unit too +++ MESSAGE ENDS +++'

The ensuing good press in the follow-up story pleases the computer algorithm sufficiently for it to return to its evil ways.

You might think I am making this up, dear reader. On the contrary, I worked in that system and helped to build it.

I am so, so sorry.

'I'm so angry that charity shop didn't let me buy blouse'

A woman is annoyed with a Worcester charity shop after they refused to sell her a blouse with a stain on it.

Mrs Browne found the top at her local Oxfam and was delighted when it was a perfect fit.

She had seen the same item in Marks and Spencer a few weeks ago for £20 so was happy to part with just £4 and put some cash into the charity's coffers.

However, the shop manager refused to let Mrs Browne buy the blouse on the grounds it had a stain on it.

Mrs Browne said she didn't have a problem with the stain and would run the risk of trying to remove it herself.

She was still unable to complete the purchase and had to leave the shop empty handed.

After being contacted by the *Worcester News*, a spokesman from Oxfam said it was against its policy to sell damaged items but has since offered Mrs

Browne the chance to buy the blouse.

Mrs Browne, of Diglis, said: 'At the end of the day, it has got nothing to do with the blouse. It is the principle of a charity shop refusing to accept money.

'I didn't care if the stain didn't come out, I still wanted to buy it. I was happy to pay full price despite the damage. You don't expect things to be perfect – that is often why they have been given to a charity shop in the first place.

'I asked the manager what she was going to do with it and she just said it was none of my business. I would rather give my money to a different charity shop.'

A statement from Oxfam said: 'It's important for our customers to be able to trust the quality of items that they find in our shops.

'Last week in our Worcester shop, an item had accidentally been put out on the shop floor that wasn't fully saleable. As soon as the staff noticed the item it was withdrawn from sale.

'Having since been offered full price for the item and because we appreciate that the customer wants to support Oxfam, the shop has decided to sell the damaged item on this occasion.

'We hope that the customer is happy with the outcome and we apologise for any misunderstandings.'

> "It is the principle of a charity shop refusing to accept money"

> "I would rather give my money to a different charity shop"

'That's disgusting' – grandmother's horror at dirty stains on mattress

Grandmother was disgusted when she discovered what appeared to be blood stains on a mattress she had just bought.

Mrs McHugh had paid out £140 of her carefully saved cash for a bed described in an online advert by Bed Solution Ltd as 'brand-new looking'.

But when she unwrapped the plastic packaging after it was delivered to her home she saw patches of staining showing through the cover.

She realised the mattress appeared to have been covered to hide the stains which, on closer examination, looked suspiciously like blood.

'I just went nuts after I saw that,' she said.

Meanwhile the hessian on the divan base was tattered and torn.

She contacted the firm to

ask for her money back and was told to send in pictures of the damage.

" I just went nuts after I saw that

'I said it was disgusting selling a bed like that to anyone,' she told the *Advertiser*.

It was only when she was told she could have a replacement but would not get it the same day that she discovered the firm was actually based in Birmingham, even though the Gumtree advert she had answered suggested the beds were in Swindon.

The advert had offered buyers the chance to view the beds in their own home before buying and promised: 'Totally in 100% Immaculate Condition (not new but look totally as 100% SHOWROOM brand new).'

Mrs McHugh kept calling the firm and was told the replacement would be with her on Tuesday, but then the delivery date was switched to Friday. The firm confirmed that delivery would be between 6.30am and 9.30pm, but then she was told the driver had left Swindon.

A spokesperson for Bed Solution said the adverts made it clear that the mattresses were refurbished. There was a quality control process and the staff who recovered the mattresses should check for fire resistance tags and damage.

The mattress sold to Mrs McHugh had slipped through the net. But he told the *Advertiser* he would be offering her a refund.

'There is no law against selling refurbished mattresses,' he said.

"
It was disgusting selling a bed like that

'Our policy is that if there is a complaint we will exchange it. It's about negotiation. We offered to exchange.'

He added that customers got a text from the driver advising them to check the mattress while he was there so they did not have to accept it if there was a problem.

He said Mrs McHugh had contacted the firm several times but not chased up the driver on Friday.

'It was his last job and he wanted to go home,' he said. 'Had she phoned him he would have done it.'

'Here's my parking fine – in 1p pieces'

A driver was so brassed off at getting a £25 parking ticket – despite having paid and displayed – that he got 2,500 pennies and dumped them on the council office counter.

Pensioner Mr Lambourne parked at Borough Parade car park on a blustery day on Saturday, February 1, and paid £1.50 for two hours. But he failed to notice that on closing his car door, the wind had taken his ticket off the dashboard.

When he returned less than two hours later, the only ticket he found was on his windscreen.

After retrieving his paid-for ticket from the floor of his car, he took it into the Wiltshire Council offices, where it was photocopied, but he was told he would still have to pay the £25 fine.

'Basically it's cost me £26.50 to park in Chippenham for two hours,' said Mr Lambourne.

So he went to his High Street bank and withdrew 2,500 pennies, weighing more than 6kg, and lugged them to the Monkton Park offices in a plastic bag.

'It was quite heavy,' he said. 'They were a bit taken aback. They asked if I wanted a receipt, did I want to wait while they counted them out, and I said "no, thank you" and walked out.

" They were a bit taken aback

'I did it to make a point. I don't like being made an idiot of. I told them at the bank what it was for and they laughed and said, let us know how you get on.'

Mr Lambourne, who drove taxis in Chippenham for twenty years, said he has been driving for forty-seven years and has never had a parking ticket before.

He said: 'I contested but it was refused. I found it a bit un- fair because I had a valid ticket.

'We used to have stick-on tickets with the peel-off back but people complained they made a mess of their windscreen, so they did away with them. Well, I think it's a lame excuse.

'Why should I be penalised just because it's made some- one's window dirty?'

Communities secretary Eric Pickles came to Chippenham in January to help Chippenham's Conservative prospective par- liamentary candidate to launch a campaign to get free parking for the town centre. An hour's free parking was removed from county car parks three years ago by Conservative-led Wiltshire Council.

" I don't like being made an idiot of

Mr Lambourne said: 'It's a rip-off parking in Chippen- ham. If you go to Corsham it's only thirty pence an hour.

'I just go into town to pass time, to have a cup of tea. The stuff I want I can't find there, I have to go to Swindon and Bath.

Clothes for men of my sort of age are pretty non-existent in Chippenham.'

A spokesman for Wiltshire Council said: 'It is the responsibility of drivers to ensure a pay and display ticket is clearly displayed when required.

'Our officers take reasonable steps to look for a valid ticket, however on this occasion there was no evidence of one on the car dashboard, on the floor or seats, and the appeal was rejected.'

Father's shock as he sees £500k overdraft after having bank account frozen

A bank customer was shocked to discover his account had been frozen with his balance showing he was overdrawn by almost half a million pounds.

Mr Livermore from Worthing found out his Barclays account had been suspended after he used his bank card over the Easter weekend.

The father of two said he cried with worry when he found out that his account stated he was £499,880.99 in debt after last being around £15 in credit.

Mr Livermore told *The Argus*: 'It is very worrying. I cried when I saw the figure. I was gobsmacked and ran upstairs to my wife and said I didn't know what was going on.

'It is confusing and stressful. I haven't been able to sleep and have been tight on money for my kids and wife.

'The fact is, they haven't even given me an explanation as to why they are holding my account. They said it is now being held indefinitely.

'It really concerns me. I have missed payments for our car finance, tax and rent because of this.

'I have been to the food bank and they have kindly helped with electricity.'

He said he was told by the bank that he could withdraw any wages from the account after it was suspended as long as he had a payslip as proof of earnings.

However, because he had transferred money to his savings account he was unable to withdraw the remaining funds.

Mr Livermore claims he lodged a complaint with Barclays but has not yet received an explanation.

He said he was told he should refer to the bank's terms and conditions in relation to suspending accounts.

He was also referred to the bank's fraud department, which he said was also unable to help him resolve the issue.

Mr Livermore said it seems his other two accounts – a savings account and a joint account he shares with his wife – have also been suspended and were showing a minus balance of nearly £500,000.

Mr Livermore said: 'I would like to know what is happening and surely if they ask me some questions, I might be able to shed some light on it.

'I manage my account every day. I hoped they would be

"It really concerns me"

able to ask me to come to the branch and sort it out.

'I have an agreed overdraft on my account of £10. If I had gone over for any reason, then they do not allow that transaction to go through because there is not enough money in the account.'

The Argus contacted Barclays to raise Mr Livermore's

> "I would like to know what is happening"

concerns after listening to a recording of his balance when he called the bank to check it, which was recorded as being £499,880.99 in debit.

A Barclays spokesman said that the bank was currently investigating the matter.

They declined to discuss it any further.

Repentant passenger fined 'outrageous' £600 for £4 train fare dodge

A train passenger who told a white lie about where he had travelled from found he had turned a £4.40 journey into an 'outrageous' £600 fine.

M r Stokes, of Cross Keys, said he knows he should have been punished for the fib but said the size of the fine is unfair considering the crime.

Mr Stokes was travelling to see Stereophonics perform in November 2015 when he caught a train from Rogerstone to Cardiff Central Station.

A single ticket between Rogerstone and Cardiff Central Station costs around £4.40 and

131

the music fan said he was planning to buy one upon arrival.

When he was stopped by inspectors at the station, he told them he had travelled from Cardiff Queen Street, 'got his story mixed up' and station staff took his details.

The customer claims he wrote to Arriva Trains Wales apologising for his first offence and asking for information on the next steps. But last month, he received a court order demanding that he pay £613 within a seven-day deadline.

The father-of-two settled the debt on a credit card without appearing in court and although he admits he 'deserved punishment' for his actions, he believes the fine is unfair considering the size of the offence.

'I found it to be outrageous, especially when you consider the fact that the society we live in fines drink drivers, burglars and people who commit GBH with considerably lower penalties,' he said.

I just don't understand how ruining someone's life can compare to this

'I just don't understand how ruining someone's life can compare to this. How can this possibly be in the same bracket?

'The penalty came nearly a year after the incident and they only gave me seven days to pay in full with no option to pay monthly or weekly as I work full time.

'I know I did wrong but I don't think it was the crime of the century,' he added.

An Arriva Trains Wales spokeswoman stated that the

company 'cannot comment on individual cases'.

" I know I did wrong but I don't think it was the crime of the century

'If a customer is travelling from a station that has ticket purchasing facilities available (a ticket booking office or a ticket vending machine), it is their responsibility to buy a valid ticket for the date and time of their journey before getting on the train,' she said.

'If not it could result in prosecution and a fine of up to £1,000. Tickets can also be bought in advance from our website and on our smart phone ticket app.'

She added: 'If caught travelling without a valid ticket, each case is reviewed in line with our revenue protection policy which can be found on our website.

'If taken to court, the fine is decided by the judge based on the circumstances surrounding each individual case. Arriva Trains Wales receives the ticket cost of the journey and administrative costs.'

Hull man's anger as he is fined for visiting Asda twice in one day

A Hull man has warned fellow motorists of a 'faulty parking system'.

A shopper has warned fellow motorists of a 'faulty parking system' in Hull which saw him slapped with a fine for visiting Asda twice in one day.

Mr Stark, who lives in Hull, went to his local branch of Asda with his mum and brother on December 23 to stock up on food for the festive period.

He returned to the same shop in the afternoon when he realised he had forgotten a number of items.

But, soon after, he received a note saying he had to pay a £70 fine – with the store saying he had parked for more than five and a half hours.

Mr Stark has spoken of his disgust at receiving the fine and said a 'fault in the system' meant the camera did not recognise he had made two trips.

'I got to the car park the first time at 8.52am,' he said.

'We shopped for around two hours and then left at 10.57am. I know that because I found the receipt from the supermarket.

"
Mr Stark threatened to do his future shopping in Morrisons instead

'I went back to Asda at just after 2pm because I'd forgotten to get some bottle bags, and was only there for about five minutes. I then received a £70 fine which said I had parked in the car park for more than five and a half hours.'

It is the second time in just weeks that an Asda car park – managed by company Parking Eye – has fined someone who made two separate trips.

Mr Stark said he had searched online and found other people who had been fined for 'double dipping' – a term created to describe people who visit the same car park twice in one day. A Grimsby woman was also fined £70 for her trip to Asda, and was accused of parking for fourteen hours.

The Hull man has appealed against the fine – which if paid within fourteen days is reduced to £40 – and said he expects it to be rescinded.

Parking Eye has responded to the story.

They said: 'We encourage people who have received a

parking charge to appeal if they think there are mitigating circumstances, and instructions about how to do this are detailed on all communications and on our website.

'In this case, we can confirm that the charge has been cancelled.'

Mr Stark threatened to do his future shopping in Morrisons instead, where he would not run the risk of a repeat fine.

He is now warning other motorists to be cautious of the car park.

'If that was my mum and dad, they would have rung up and paid it,' he said.

'I knew I was not paying. I would have let them take me all the way to court before I parted with any money.

'My advice to other people would be always dispute it – if you know it is wrong don't just pay it.'

" I knew I was not paying

'If that was my mum and dad, they would have rung up and paid it,' he said.

Grange Hill star's business struggling after online banking 'fiasco'

Lee has owned the locksmith's since 2000, 13 years after his last *Grange Hill* appearance.

Former child TV star Lee MacDonald, possibly better known as Zammo from *Grange Hill*, has labelled TSB's online banking service a 'fiasco' after an online error cost his business a large amount of money.

The British bank took down its mobile app and online services on Monday, April 23, in an attempt to fix technical problems which have locked customers out of their accounts.

Lee is now the owner of a successful locksmith's, but he says the past week has been incredibly difficult after being unable to use his online banking service.

'I was quite excited about the new app that was being launched by TSB online because it would make my banking a lot easier,' explained Lee.

'But when I tried to log in on Sunday, I found that I couldn't log into the app or the online banking site. I use online banking for everything I do, whether that's paying suppliers or getting paid myself, so it's incredibly frustrating.'

Lee explained that he had to cancel some jobs earlier in the week, and that the problem is far more than a short-term one.

'If we cancel, they'll go to someone else, and if that person does a good job, it could mean that we lose customers,' he stressed.

'I've tried to call the customer service team several times, but every time I do I'm on hold for 45 minutes and I get nowhere. I've been told it will be sorted by the end of the week but by that time I may have lost a lot of custom and I can't afford to do that.'

Lee has owned the business since 2000, after his partner at the time convinced him that buying a locksmith's was a good move.

He says his local branch of TSB has been incredibly helpful, and that he doesn't blame them in the slightest.

'I want to make it clear that I am very happy with the service I have received from my own branch,' he said.

'It's not their fault that the online system isn't working, and although I was unable to cash some cheques when I tried because of the online problems, they were still very helpful.'

Lee has appeared on several national media outlets to

"it's incredibly frustrating"

talk about the issue, and admits it has all been a bit of a whirlwind.

'It all started when I tweeted TSB's CEO, Paul Pester, saying I was very unhappy with the service,' he explained.

'I then got a call from BBC Radio 5 who wanted to speak to me, and since then I have been interviewed by ITV and a couple of national newspapers.'

Lee is still on the lookout for acting jobs, but stresses that it's hard to do that when his main source of income is experiencing so many issues.

TSB's CEO Paul Pester said: 'Our teams continue to work around the clock to fix the problems that some of our customers are having in accessing their TSB accounts.

'I want to reassure our customers that the engine room of the bank is working as it should. This means that for the vast majority of our five million customers, everything is running smoothly.

'They can do their day-to-day banking, such as using their cards to get money out of cash machines and paying for goods with their debit or credit card in shops both on the high street and online. All of the services that happen every day such as direct debits, standing orders, payments including salary credits, and transfers going in and out of accounts are working as normal.

'The challenge we are facing at the moment is that while we know everything is working, one of the main ways that our customers see everything is working – through our internet banking and mobile app – isn't functioning as

> "I've tried to call the customer service team several times, but every time I do I'm on hold for 45 minutes"

well as it should be, and for this I'm truly sorry.

But what has Zammo been up to since Grange Hill ended?

Since appearing in his final *Grange Hill* episode in 1987, Lee continued to appear on TV in shows such as *The Bill*, but after buying the locksmith's, his acting slowed down a bit.

He admitted that he is still definitely best known for his role as Zammo, and that for some time the association annoyed him.

'It used to get a bit grating when people would come up to me all the time and shout "Zammo" at me, but as I've got older, I've been able to appreciate just how important *Grange Hill* was to a lot of people,' he said.

He spoke of fond memories of visiting the White House to meet the then first lady, Nancy Reagan, and all the good times that his role in the show brought him.

'*Grange Hill* was a huge part of my childhood, and now that I'm nearly 50, I can look back on it and understand what being a part of the show meant to me,' he explained.

He attributed his ability to remain in contact with a lot of his co-stars to social media, and mentioned that a '40 years since *Grange Hill*' party is going to be held.

Thanks to his locksmith business being a success, Lee says he is now able to start looking at more acting jobs, and that he signed with a new agent last year.

'The acting has always been something I've wanted to continue, and so the more successful the shop is, the more time I have for acting,' he said.

'The last 18 months have been

> "It used to get a bit grating when people would come up to me all the time"

really positive for me. I starred in a film called *Freehold* last year, in which I played a locksmith. I would have been really disappointed if I hadn't got that role!'

Lee is also currently in an advert for McDonald's, and his agent is in the process of trying to get him a role in an upcoming sitcom.

> "I think to most people I'll always be Zammo"

'I think to most people I'll always be Zammo. It does great things for the shop, and as I get older I'm just so grateful I was able to be a part of it,' he said.

Council Issues

FACT (which I may have just made up): Every single person who rings up the council to say that nobody has been to empty their bins is only doing so because they forgot to put their bins out.

ALSO FACT: Doncaster Council tweeted it (so it must be true) that everybody rings in at some stage in their life to complain about bins. Lord knows, I have, and I don't even live in Doncaster.

Top residents' issues reported to us by number:

20. Each
19. report
18. from a resident
17. is
16. as important
15. to
14. us
13. as the
12. next
11. so
10. we will
9. never
8. differentiate
7. whatever the
6. number
5. of
4. reports
3. we
2. receive
1. Bins

And despite the extraordinary numbers of people calling their council offices to complain about bins, there are still sufficient numbers of people who know the one and only way to get action and get it NOW: Their local newsroom on speed dial.

These are the people who expect the local council to run every aspect of their lives on their behalf, and will immediately run to the press the second that those alleged pencil-necked desk jockeys at the town hall fail in their duty.

In local council circles (and let me tell you right now that I have canvassed a great many council workers and at least one mayor) these people are known as 'a complete and utter pain in the arse' and 'this is the reason we can't have nice things'.

In local newspaper circles these people are referred to as 'the Picture Story on Page Five'. For serial complainants the paper may even have a number of stock photographs which will save their photographer from having to go to their barbed-wire surrounded house and get an ear bashing about the state of the world and 'how Nigel's going to save us all'.

What reporters will find almost immediately about any complaint that should be directed to the council is that it has not been directed anywhere near the council at all. In fact, the phone call the reporter makes to the correct official at the council is probably the first they've heard about an overhanging branch that might kill a kiddiewink.

This is because most people who complain about council matters to the local press assume that council officials with their (and we quote) 'gold-plated pensions and foreign holidays' are somehow psychic and omnipresent, and know about any particular problem even before it happens.

Mr/Ms/Mrs Complete and Utter Pain in the Arse (favourite phrase: 'Speaking as a council tax payer . . .') being the only person in the whole town who pays council tax, takes it as a personal slight that a light can still be seen in the stairwell window at the council offices at three in the morning, and is therefore costing them money, personally, now.

Things that also annoy people who think the council should do

everything with the limited pot of money they need for running social care, libraries and other stuff:

1. Not mowing the grass verges, especially the one outside my house.
2. Not fixing the leaky roof in my bathroom, even though I haven't actually called the housing association about it in three months.
3. Not picking up every single instance of dog mess in the 300-yard walk from my front door to the letter box where I post my daily letter to the council offering advice on how they could be running their affairs more efficiently for the benefit of people like me, and just wait until the *Evening Post* hears about this, it's going to blow the whole tin lid off your corrupt organisation.
4. Stopping people from enjoying themselves by building tree-houses on their own property for the kiddiewinks.
5. Stop people with kiddiewinks living near me.
6. Actually, stop anybody from living near me.
7. Bins.

But you will be amazed to hear that not every person who goes to the papers about their local authority is a serial complainer.

Oh no, there's another one per cent or so who have gone to the press out of frustration that despite their very best efforts not to bother contacting the council, nobody's turned up to trim their bushes (not sexy slang) that night cause an oldiewonk to take a bit of a tumble (also not sexy slang).

These people, as rank amateurs in the Complaining About The

Council game, will point at anything in their quest to be the Picture Story on Page Five, and are then all the more likely to be the ones defending themselves in the comments on the online version. These people are not there for mockery. These are modern day heroes, ready to defend themselves from the keyboard warriors who form the bulk of local newspaper commenters.

If it were not for local councils and their inability to employ psychics who have remote sensing abilities to spot leaking roofs and unemptied bins, then these people would not come out of their shells and be prepared to complain and defend themselves in the public sphere.

In that sense, the real heroes are local newspaper editorial staff for allowing them this unique opportunity.

You're welcome.

Council accused of wasting energy as office lights are 'left on all night'

Bin bags full of rubble have also been left on one end of the car park for a month, a resident claims.

Cornwall Council has been accused of wasting energy at one of its offices as residents claimed the lights are left on all night and windows are left open when the heating system is on.

Bin bags full of rubble have also been left on one end of the car park for a month, it has been claimed.

A resident of Bodmin made both discoveries while walking his dog in the town's Beacon Technology Park – where

Cornwall Council built its Chy Trevail office in 2015.

The scrap man said that many lights, on the floors and in the staircases, could be seen from outside the building every day at different times of the night.

He also claimed that a lot of windows were left open all night and he could hear the heating system running.

He described the discovery as 'frustrating' and 'annoying' and sent a dozen pictures to *Cornwall Live*.

'I was taking loads to prove that that's every day, it's not just one-offs,' he said.

'Some will say I'm petty, but no, I work hard, I have to work every day to pay for that and the council tax. I am annoyed. They keep saying, "Can't do that, don't have any money," while this happens every night, seven days a week.'

He said that he usually walked his dog late at night around 10.30pm and very early in the morning and that the people he meets on the walks also talk about it.

He added: 'It is frustrating, especially as I spoke to someone from the council a month ago.'

The local resident also showed *Cornwall Live* bin bags left at the end of the car park which seem to be full of rubble and could have been there for a month, according to his complaint.

> "it's not just one-offs"

'Fly-tipping at Cornwall Council, you can't make it up,' he said. 'Someone must have seen it, but it's been there for a month.'

Cornwall Council said it might be due to an issue with the building's lighting sensors.

'Chy Trevail is fitted with light and movement detection sensors and the heating is managed by a timer programmed in line with building operating hours and a temperature

sensor system,' a spokesperson for County Hall said.

'We're aware of an issue and we're working hard to diagnose and repair an intermittent fault with some of the lighting sensors within the building, which unfortunately has resulted in occasions where lights have come on outside of normal operating hours.'

> "Fly-tipping at Cornwall Council, you can't make it up"

They also said the waste will now be removed as soon as possible. The spokesperson added: 'Site inspections take place and particular attention will be given to removing any waste that has been left on the site.'

Pensioner rages at 'ghastly' four-foot ditch left outside his home

A pensioner who is worried about a four-foot ditch outside his home is 'waiting for someone to have the first accident'.

The large hole has been 'left' by the council and, according to residents of a hamlet in Harlow, looks 'absolutely ghastly'.

Mr Garbutt feels the area has been destroyed after the council conducted works on pipes and water systems in the area.

He said: 'Our area has been decimated. We now have a 100-yard by four-foot ditch which is going to stay.

'When I tell people about it, they don't believe it is staying as it looks absolutely ghastly.'

Mr Garbutt, who has lived in his

home with his wife since 1978, was not concerned over the ditch when works first began.

" Our area has been decimated

He believed once the project had been completed the hole would be filled for safety reasons but has been told it will remain open.

Mr Garbutt said: 'It's absolutely disgusting what has been done.

'We are just waiting for somebody to have the first accident and we will call an ambulance.

'You might think with health and safety in this day and age, I couldn't believe they left it the way they have.'

The ditch was funded by Essex County Council as part of essential prevention works that Harlow Council are carrying out to 'protect local homes and areas from flooding'.

The ditch, which stretches along the road, was present in the 1970s prior to the homes being built. However, it was filled in and hasn't been there since Mr Garbutt and his wife bought the property.

Little Cattins is close to a primary school and a gymnastics club, so he is concerned that a child could get hurt.

He added: 'The ditch has pipes showing for drainage which children are using as bridges.

'We had our councillor round and he has taken pictures of it, he couldn't believe that the ditch will stay open.'

He is also concerned about what will happen if he and his wife ever want to sell the property.

He continued: 'I have been here since 1978. We don't intend to downsize, but if we did

sell the property the starting price will change quite a bit.'

" It's absolutely disgusting what has been done

An official Harlow Council statement said: 'The ditch is to protect the surrounding homes and area from surface water flooding.

'It is essential flooding prevention work that is being funded by Essex County Council. The boundaries of nearby homes will not change, it is simply reinstating a ditch which was in the area before the homes were built in the 1970s.

'The ditch connects to a local pond and will store water during heavy rainfall, helping to prevent local homes from flooding. At the same time we are also carrying out other improvements to the local environment to encourage and benefit the local wildlife.

'This includes cutting the trees and hedgerow which will regrow thicker and bushier. New fencing has also been put up near the pond and more fencing will be put up around the pond in the next couple of weeks.

'Local residents have been informed of the work taking place.

'Unfortunately there have been some delays to the project's progress and disruption to the area while work has been carried out.

'However, the appearance of the area will improve as we move into spring and the summer.'

'My beloved dog Snowy will be torn apart by foxes if council chop my fence in half'

Mr MacKay has described the Jack Russell Terrier as his 'baby' and he is desperate to protect him at all costs.

A grandad-of-six is in hot water with the council after doubling the height of his garden fence to protect his beloved Jack Russell Terrier from being killed by foxes.

Mr MacKay used donated planks of wood to build an extra three feet of fencing around the garden of his bungalow in Hull. He moved into the property six weeks ago with his

ten-year-old dog Snowy, who lives in a purpose-built hutch in the garden.

When he got the keys, Mr MacKay said he spoke to a housing manager who he claims gave him the all-clear to make his fence six feet high. However, he has now been told by Hull City Council that he did not have permission to build the fence higher as he shares his garden with neighbours.

Mr MacKay is desperate to maintain the tall barrier so he can keep Snowy safe, as he is convinced foxes will jump into his garden and tear apart his treasured terrier.

He said: 'Foxes do pose a real danger. They will kill anything they get their hands on. The woman next door but one to me feeds pigeons there so the foxes come for them and most of them are bigger than my dog.'

'I'm worried that they will kill Snowy and feed him to their babies. If they did that would really upset me and if I had to reduce the fence back to three feet I wouldn't keep him because it's not safe.

I wouldn't want to risk his life at the hands of these foxes or anybody else really because somebody could just come in, pick him up and walk off with him.'

"I'm worried that they will kill Snowy and feed him to their babies

Snowy, described by his owner as a 'soft dog who wouldn't hurt anybody,' has always lived outside after being nurtured by a farmer who kept him outdoors.

The pair are close and Mr MacKay says he wants to enjoy

the rest of the time he has left with Snowy. 'He's my baby,' he said. 'He has gone a bit grey in his eyes and he has got a bit of arthritis now too.

" He's my baby

'The council came last Thursday and said I needed to take it down but I said, 'Where is my dog going to live?' He said, 'We don't house dogs,' and I said, 'I'm the one who feeds him, takes him out for walks and looks after him.

'I would have to get rid of him if the fence was reduced because it's just not safe and I really don't want to do that.'

Mr MacKay said he has received no complaints from his neighbours about the extra security measures put in place. However, Hull City Council has said that his fence cannot be more than three feet high.

A spokeswoman said: 'On viewing the property, Mr Mac-Kay asked about fencing the garden and was told that he would have to submit his request in writing.

'He did not and went ahead installing six-feet-high fencing. He was subsequently visited by a local housing officer and informed that he could not section off parts of the garden because it is a communal garden, and in an area where a conservation order states that any fencing should not be above three feet high, and therefore he has been asked to remove the fencing.'

Anger as dog walkers steal second sign in two days from Devon beach

'Let me make it perfectly clear – this is a dog-friendly village.'

'Why won't you share?' This is the question that has been levelled at 'militant' dog walkers who are believed to have stolen signs at a popular Devon beach – for the second time in just two days.

On Monday we reported that vandals had defaced code-of-conduct signs highlighting new dog restrictions at Instow beach over the weekend.

And yesterday yet another sign was removed, meaning just one of the three signs is now left – and even this one has been vandalised.

The chairman of Instow Parish Council has overseen

the introduction of the code of conduct which restricts dogs to around seventy-five per cent of the beach at high season between May and September.

Councillor Moores says he was saddened by the initial damage and theft of the signs – and is further frustrated by the latest removal of a sign located about half way up the beach on Marine Parade.

Speaking to *Devon Live* from the beach yesterday he said: 'We know two signs have been removed and the third has been vandalised.

'We put them up on Saturday – the one by the slipway was removed on Monday morning and then the one in the middle of the beach went on Tuesday morning.

'It's extremely disappointing. We've worked hard with parishioners, we had a

> "I'm disappointed that the dog lobby has stooped to such depths"

survey done which overwhelmingly asked for some sort of restrictions and we have consulted the public all the way through.

'The dog alliance have vented their views at parish council meetings, they've been disruptive, they've not done it in a way where we can discuss and talk – all they've said is that they are not having any restrictions at all.

'Let me make it perfectly clear, Instow is a dog-friendly village. All we're trying to do is have some form of control and sharing – that's all we're trying to do.'

One resident who has also been vocal on the matter says the 'militant' dog walkers are 'making life hell' in the village.

He said he was 'disgusted' that the signs – which he helped to erect – had been removed and damaged.

He said: 'I'm disappointed that the dog lobby has stooped to such depths.

'Verbal disruption at parish meetings is one thing, but the vandalising and theft of council property from our beach is abhorrent and disgusting. I would like to see the law come into play and have the people who are responsible brought to book.'

An Instow resident and dog owner said he doesn't understand what the problem is.

He said: 'It's entirely sensible and reasonable that a section of the beach should be reserved for families without dogs for five months of the year.

'If people want to have their dogs and families on the beach, walk that way – if you want to have a dog-free time for five months of the year, you've got the other side.'

The first resident added:

'I have one question for the people who are stealing and vandalising the signs and making life hell in this village: why won't you share?'

The decision to introduce dog restrictions was made after the council received complaints from families who had been using the beach.

The council conducted an independent survey of all residents last year asking them their thoughts about dogs on the beach.

The response rate for the survey was fifty-two per cent, with seventy-four per cent saying they would welcome dog restrictions during the peak summer months.

Councillor Moores said: 'The survey came back with the overwhelming response in favour of some form of restriction on dogs.

'It's not a ban; it's just a form of control and restriction. Instow is a dog-friendly

> "why won't you share?"

village and we want to maintain it as that, but we can't have a free-for-all and that's what it's becoming.

'We have a duty as a parish council to ensure everybody using amenities is welcome, but in some situations you have to have restrictions to make it work.'

Here's the wording as it appears on the signs:

Dogs are allowed without restriction on the areas of the beach coloured gold on the map.

Dogs are not permitted on certain sections of the beach from 1st May to 30th September each year.

The restricted area is highlighted in pink on the map and stretches between the Quay and Lane End Road.

Dog owners must keep their dogs in sight and under control at all times.

Dog owners must clean up after their dogs at all times and dispose of the result in the dog litter bins provided.

One of the arguments put forward against the restriction of dogs on the beach is that businesses in the village will suffer.

We asked the councillor what he thought about that.

He said: 'I don't see how business would suffer. I've spoken to several businesses along the parade and they have no problems with the restrictions.

'Dog walkers will still come here and they still have the majority of the beach to walk their dogs on.

'I really don't see how businesses will suffer.'

Are the restrictions enforceable? In short, no. But Councillor Moores hopes locals and visitors will respect them.

> We can't have a free-for-all and that's what it's becoming

He said: 'We would expect the community to abide by the code and hope people will respect these rules.

'The code is there for our village after all. I don't believe enforcement would actually work – no one is banning dogs, there's still loads of space for dogs and walkers.

'Instow is definitely still a dog-friendly village.'

Woman fears giant tree is going to crush her house

Frustrated Christine says she will not foot the bill for any damages caused.

A fuming Plymouth woman is living in fear that a large tree is going to crush her property and cause serious injury.

The resident, who has lived in her town for fifty years, says that she 'wants the tree down' before disaster strikes in her road.

The tree, which is several years old, has been a nightmare for Christine and her neighbours for ages.

She said a branch which collapsed years ago could have killed a child if her late brother's car hadn't been in the way. Now she's demanding the council take action once and for all and banish it from the community.

The council has yet to respond to *The Herald* about the saga.

Disgruntled Christine said: 'I'm not the only one who wants the tree in this street gone. It is bending over on to my house and its roots are lifting up the car park and my driveway.

'I've been on to the city council for years and years about the tree outside my property.

" I'm not the only one who wants the tree in this street gone

'When my brother was alive one of the main branches came down from the top and if he hadn't had his car there, it could have killed a kid. After he passed away, I still carried on with trying to get it moved or cut down.

'They don't want to know because it's a healthy tree, but they'll cut down healthy trees along other streets and pavements that belong to Plymouth Community Homes. There is no way there is a law for one and a law for another.

'My hope is to get it down all together and get the roots up, then they can't cause anyone to fall over on my pathway or trouble for my water mains.'

Several other trees in the area have been removed due to the redevelopment of the town to make way for the fifth phase of development in the area.

" There is no way there is a law for one and a law for another

The Herald recently reported how Woodville Road has become a ghost town as families who have lived on the street for decades have been moved out to make way for the 143 new homes planned for the site. The large scale regeneration scheme, one of the biggest projects of a generation, is due to be completed by 2020.

But with this has come the news that many healthy trees – believed to be more than sixty – have had to be chopped down. Trees across the road from Christine's property have been felled – but these were owned by Plymouth Community Homes.

Plymouth City Council said: 'We are aware of Ms Horton's concerns and will be contacting her directly to deal with her enquiry.

'As always, we would advise all residents who have an issue with trees to contact us directly by using our online self-service system as this is the quickest and most effective way of ensuring that the relevant team is notified.'

162

ANGRY PEOPLE IN LOCAL NEWSPAPERS

Residents want to bring an end to thorny battle with Wiltshire Council

Residents living in a Trowbridge housing estate are at the end of their tether with overgrowing brambles on their road.

According to a retired milkman who lives in the estate, residents have been battling Wiltshire Council over the problem for a decade and now want action to be taken.

Mr Collins said: 'We have been battling the council for over ten years but they have done nothing about it.

'It's untidy and it's blocking the back gate of someone's garden. If there was a fire in their house which blocked them from getting out of the front door, they certainly wouldn't be able to get out the back as the bushes are blocking their exit.

'It has been going on for too

long now and we are fed up. I have been out to cut it a few times and so has my son, but we want a permanent solution.

" We are fed up

It's unsafe as there are lots of brambles sticking out which could easily catch someone in the eye, and it also looks bad.'

A Wiltshire Council spokesperson said: 'This area was already programmed to be cut back soon, however we arranged for it to be done earlier this week, which will hopefully help with some of the issues.

'We would remind residents that they too have a responsibility to maintain their own gardens and land so it doesn't encroach footways, roads and other people's properties.'

Brambles are a common problem, especially in neglected areas or under hedges.

They can be difficult to eradicate once they have become established and Mr Collins thinks that just cutting them will not get rid of the problem due to this trait.

He said: 'Simply trimming the brambles isn't good enough – it will just grow back, as we have seen many times over the years.

" I'm not an expert so I don't know what that solution is

'We need a permanent solution or we will be in the same position again. I'm not an expert so I don't know what that solution is, but I know that just cutting it back won't solve the problem forever.'

'I told the council about dangerous paving two years ago – and it's still not fixed'

He says all the city centre should have been repaved for the City of Culture.

A Hull man says 'dangerous' city centre paving has still not been repaired despite first raising his concerns two years ago.

Mr Applegate told us he has fallen in Prospect Street due to uneven paving slabs twice, but despite reporting it to Hull City Council, he says nothing has been done.

The retired marine electrician said: 'Just about every day I walk into town and

do my shopping in Prospect Centre. You can just see the pavement is uneven, it's shambolic in some places.'

'It causes a problem for people with pushchairs and mobility scooters . . . I've seen [people] almost take a run up at it to get over some of the paving on Prospect Street.'

Mr Applegate, who lives in west Hull, said he wrote to councillor Stephen Brady more than two years ago about his concerns. In his response, the then leader of Hull City Council told Mr Applegate in January 2016 his letter had been forwarded to the council's Highways Department.

But two years after Mr Applegate told the *Mail* he felt his concerns had been ignored by the council, nothing has changed to improve the paving.

Photos taken this week and those taken in 2016 show there has been very little change to the pavements in Prospect Street during the two-year period.

Mr Applegate believes the work done in the city centre as part of 2017 City of Culture year should have looked to improve the city on a wider scale.

He said: 'They've put ornaments up recently in the city, like the new sculpture in Queen's Gardens, but rather than a new ornament I'd prefer to walk safely in the town.'

Mr Applegate said he was pleased with the paving work done in Victoria Square and beyond, but said it should not have stopped there.

He said: 'They did all that work for Hull City of Culture and what they did in and around Victoria Square looks great, but they only did up to Story Street, is that where the City of Culture stops? It all needed doing.'

In response to Mr Applegate's claims, the council urged members of the public to report

"it's shambolic"

any issues to them so work can be done.

A spokesman said: 'Members of the public are encouraged to report loose blocks and pavings

> "I've seen [people] almost take a run up at it"

found in public footways so the Highways Team can ensure these are either repaired, replaced or made safe at the earliest opportunity.'

Field looks 'like the Somme' after developer changes land

Reigate and Banstead Borough Council's enforcement officers have stepped in.

A developer has been accused of turning green belt scrub woodland into a scarred landscape akin to the aftermath of the Battle of the Somme.

Residents in Lower Kingswood are furious after a field thick with vegetation was cleared and the earth piled up.

While within his rights to clear the land, the owner did not have permission to change the shape of the landscape and Reigate and Banstead Borough Council has now ordered him to reinstate the land.

Nearby residents were horrified when heavy machinery cleared trees and thick scrub from the large field last month and their cause was also taken up by a Reigate MP, who expressed his horror.

One lady who has lived in the area for more than forty years said: 'How can green belt

land be destroyed like this, and nothing can stop it? I think the council have been very good, but it happened so quickly, they couldn't do anything until the earth had already been vandalised.

"
It looks like a battlefield

'It looks like a battlefield, it looks like the Somme, I have never seen anything like it. It is unbelievable.'

The MP called the works 'a shocking piece of environmental vandalism'.

Residents said they were initially told that the land, which once had post-war prefabricated houses on it, was just being 'cleared'. Their alarm grew, however, as earthworks took place and large red gates went up.

But the owner, a developer with a portfolio which includes flats and houses in the Croydon area, has told *Get Surrey* he hopes to build homes on it.

A borough councillor for Kingswood and Burgh Heath has been keeping in close contact with residents as matters have unfolded and said a lot of anguish would have been avoided if neighbours had known about the works in advance.

'To get up in the morning and look out and see bulldozers smashing down trees is, I think, really upsetting for people,' he said.

'That was the feeling in the first couple of weeks. People were literally looking and going, "Oh my God, what is happening there, that is awful."'

"
I have never seen anything like it

The director of the property development company, which recently bought the land, said: 'We are currently evaluating the site. We will be working with the council and all interested parties to develop an application for a sympathetic residential scheme. This will include affordable housing and self-build units.

'We are in the early stages but would welcome all contributions of ideas that will benefit the local community.'

The deputy development manager at Reigate and Banstead Borough Council said the authority first received reports in March about work to clear trees and scrub on the site.

He said: 'Whilst the land is in the green belt there was no breach of planning control in the work that was ongoing at the time.

'The council has not received a planning application for this site, but having received further reports of changes in [ground] levels we followed up with further investigation and met with the owners.

'The changes in levels on the site and the gates that have also been erected, in the council's opinion, amount to engineering works that require planning permission and are in breach of planning control.

'We continue to investigate and are currently waiting for confirmation from the owners that the grading of the land will be reinstated and the foundations of the historical development that had been uncovered be covered back up. We hope that this will be resolved through co-operation but the possibility of more formal action also remainsan option.'

Since providing their statement, the council has received a formal application for pre-planning application advice.

Newly fitted lights could harm children's eyesight

'Risky' lights fitted to bollards as part of Worcester's riverside spruce-up are to be safety checked after claims they could damage children's eyes.

The LED (light-emitting diode) lights were fitted in the new bollards at Diglis Parade and Kleve Walk by the river Severn, last year.

Mr Arnold, an engineer and former scientist, told the county council last autumn the low-level LED lights posed a risk to young children's eyesight if they stared into them for too long.

He wrote to Worcestershire County Council, and they carried out independent lab tests which they say confirmed the lights 'met the British Standards and European Codes of Safety'.

However, they accept there is a risk, albeit one they have qualified as 'slight', if a young child in a pushchair was left twenty centimetres or closer and looked into the light for a sustained period of roughly more than a hundred seconds as children's eyes are more sensitive than adults.

In his letter, Mr Arnold said that the lights' manufacturer, Phillips, classed them

in the moderate risk category if stared at from a distance of less than a foot.

He also wrote to the Health Protection Agency (HPA), and the HPA-affiliated Centre for Radiation, Chemicals and Environmental Hazards has suggested a diffuser be applied, or the brightness reduced.

Mr Arnold said: 'The HPA say advice has been given and the council needs to come back with something that is safe.

" if it can happen it will happen

'It is a concerning issue, and I am not alone in highlighting the glare of those lights. The council have introduced something that is going to be there for some years, and it is a hazard which must be addressed.

'By saying it is a slight risk – well, my answer to that is if it can happen it will happen.'

Mr Arnold says there would be no issue if the council had installed the taller ordinary streetlight columns, as the light would be spread out while still lighting the path and river bank.

A county council spokesman said: 'Despite the extremely low risk levels and unlikelihood of such an occurrence, we're looking into whether alterations might be possible to reduce this low risk even further.'

As we previously reported, residents of Malvern have complained new county council LED streetlamps in their road have lit up their homes 'like a football stadium'.

The county council fitted a cover on one of the streetlamps to dim the light following residents' complaints.

Smelly bin taken away after a year

Residents have rejoiced after a stinking bin full of rubbish was cleared from a council block forecourt after a year.

In Wednesday's paper we told how local resident Mr Gardner has complained to bin men and the council about the situation.

He said he and his fellow residents of the area in Brighton were 'up in arms' over the 'stinking' bin, which fell off a lorry while being picked up last summer and has been left out ever since.

It was removed by City Clean staff at 3pm on Thursday.

Yesterday Mr Gardner said: 'It shouldn't have taken so long but everybody's very pleased it's gone.

'I'd like to thank *The Argus*. It's a sad situation that it only got solved after the paper got involved – I really think otherwise it'd still be there next summer.'

Queens Park ward councillor Adrian Morris said he had been informed the matter had been dealt with.

He wrote: 'Please remember that if a resident contacts

> "It shouldn't have taken so long"

any councillor first we can react quickly and get issues resolved. We also have many contacts on the council who we work with on a daily basis. That also includes all emergency services.'

This is the fourth time in a month Brighton and Hove City Council has responded swiftly to a matter raised by *The Argus*.

Editor Arron Hendy said: 'It's great to see the council being so responsive and we'd like to thank them for acting so quickly on matters of concern to *Argus* readers.'

Several weeks ago the council found space for children who had missed out on a place at either Dorothy Stringer or Varndean school. After initially saying temporary classrooms would be impossible to build before September, the

> "It's a sad situation that it only got solved after the paper got involved"

council came to a cross-party agreement after *The Argus* contacted opposition councillors over the issue.

Last week Mr Yates, the incoming council leader, tweeted after a series of *Argus* articles on the state of the city's public toilets: 'I've just been for a sniff around Pavilion Gardens public toilets. Clearly a big investment is required to bring them up to modern standards. But despite their failings I found clean toilets.'

Days later, the council announced a £1 million investment to renovate public lavatories.

And last week Councillor Yates had recycling bins placed in the foyer of Hove Town Hall after *The Argus* reported Green Party councillors were critical of the availability of recycling facilities.

The Top Ten of Angry People in Local Newspapers

No.1 Couple's Virgin Media service cut off after somebody hacked into their account and watched porny movies without paying for them. Three times.

Meet Ron and Ann. Persons unknown somehow hacked into their Virgin Media account and used it to view late-night movies of a pornographic nature on multiple occasions.

In 2009, 2012 and 2014, in fact.

And they're simply not going to pay the £900 that Virgin Media say they owe. Why would a retired lorry driver and his wife even want to watch that volume of scud when you can get it in ample quantity, for free, on the internet (so I'm told)?

Everybody on God's cold Earth knows that Ron is innocent and that something has gone horribly, horribly wrong at Virgin HQ. Yet, once again, The Man refuses to concede

that they would have made a mistake.

However, there are mischief-makers in this world determined to bring calumny and grief down on this sweet couple because of a single photograph which – they say – tells a completely different story.

"He knows something," people say, leaving their implication clear.

They are wrong of course. Ron was simply not ready and was caught out by the camera flash.

Ron is innocent, and this is the hill on which I am prepared to die.

No.2 Naked neighbour has put me off sausages for life

This is the article that sparked the idea to start the A P I L N blog, so I think it deserves a second mention.

Denise is, by all accounts, a mild-mannered resident of a western suburb of Reading.

Her life was turned upside-down and inside-out the day her neighbour decided to do a bit of gardening wearing nothing but a pair of old boots.

On multiple occasions.

"I would see him two or three times a month, naked, mowing the lawn or cleaning the window, always naked apart from a pair of boots," she told the Post.

"Put it this way – it has put me off my sausages for life."

Of course, this would have been a run-of-the-mill court report had the paper not asked for a photo of Denise displaying her fear of sausages in the most literal manner possible.

The question which remains is whether the sausage was the model's own, or whether the photographer turned up with a raw sausage on a fork ready for the shoot.

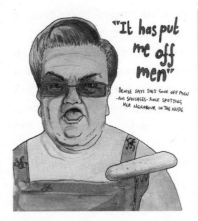

"It has put me off men"

DENISE SAYS SHE'S GONE OFF MEN -AND SAUSAGES- SINCE SPOTTING HER NEIGHBOUR IN THE NUDE

We will never know, because we have been completely unable to track down the brave photographer, so we had to draw it instead.

No.3 'We're sick of this' – Residents deliver dog mess to mayor

Dog poo stories are ten a penny in local newspapers, so it's going to take something very special indeed to crack our top ten. And here it is.

Katherine here is sick of the fact that the authorities in her community on the northern tip of New Zealand's South Island don't appear to be taking the problem of dog mess particularly seriously.

She and her friend Ray are on a mission to solve the problem, and from the photograph it's one hell of a sacrifice for her to take.

'It is one big dog toilet down there,' the campaigning duo say.

You may wish to copy Katherine's expression by simply sucking on a lemon, then trying to pick up a handful of dog crap.

No.4 He left a dump instead of a tip – Taxi driver's crap night out

To be honest, we could have chosen any photograph from Darwin's NT News, because

Australia's Top End is a very weird place in which to live.

Also, their photographers are supremely skilled in the dark arts of the angry local newspaper photograph, especially when faeces, UFOs, crocodiles, booze, or a combination of all four are involved.

But here's taxi driver Kishan Lalka reliving a shift he's never going to forget in a hurry, in which he turns around to find a fare doing what the fair people of Glasgow call a 'jobbie' on his back seat.

Because of questions of good taste, we've declined the kind offer of a photograph of the bottom used in the Crimewatch-style reconstruction,

because some of you may be of a sensitive nature, and may find the sight of an arse with a large mole on the left cheek somewhat disturbing.

Lord knows that we do.

No.5 'I almost fell in it': Royston slimmer's disgust at line of dog poo left at bus stop

Like we were saying, dog poo stories are ten a penny, so it's entirely down to the photograph to turn it into a classic.

And Slimming World rep Lynsey came up trumps with her epic kneel-and-point at a pile of turds in Royston, Herts.

'Live happy!' screams her Slimming World Bag, but the look on her face shows that she is not living happy at all.

And not only is she pointing, she is also thinking of the kiddiewinks: 'It looked like a horse had done it. It's terrible. What if a child was there and fell in it?'

I would dare say that the kiddiewink would have been covered in dog poo.

And while we're here, if you're a member of the Slimming World cult, you may wish to consider my foolproof plan to win the Slimmer of the Month prize.

> *Weeks one & two: Go to your weigh-in with your coat pockets filled with heavy fishing weights and builder's rubble*
> *Week three: Go to your weigh-in with your coat pockets filled with just the fishing weights*
> *Week four: No weights or rubble. You cult coordinator will be amazed, and the Slimmer of the Month cake will be all yours.*

No, you're welcome.

No.6 Gravesend couple sleeping in garden after thieves steal gate

We've all been there. One minute you're living the life of Riley in your two-up two-down somewhere in suburbia, and the next you're taking it in turns to sleep on the driveway to guard your stuff in case the thieving curs make a return trip.

And they're right, because everybody knows that the theft of gates is a gateway crime.

The more observant among you will note that among their 'stuff' is a potato impaled on a stick, one of Tracey Emin's earlier works, now valued at over £10,000.

'Ah-ha!' I hear you ask, 'why don't they just take the potato impaled on a stick indoors?'

You idiot.

The full title of the work is Potato on Stick next to Garden Swing Seat on a Driveway in Gravesend. You'd be wrecking priceless, award-worthy art. This being the case, our hero here is doing God's work.

No.7 Biscuit lover stunned to find plain digestive in milk chocolate pack

We'll be the first to admit that this photograph was conceived and executed on the pages of the Angry People in Local Newspapers Facebook group (You should join, it's excellent!).

'Ahoy hoy!' James said in the traditional Pompey greeting, 'I've had this life-changing problem with a packet of biscuits, and I was wondering if I should take a photograph, pointing at them in an angry manner and send it to the local paper in Portsmouth.'

'Yes. Yes you should,' we said.

So he did.

Although we consider James nothing short of a BLASPHEMER for even considering a purchase of milk chocolate digestives, because plain ones – as we all know – are God's own choice, we cannot fault his commitment to the cause by producing an absolutely textbook news photograph.

'I was quite surprised. It's the last thing you expect to see,' he told *The News*, unaware that other last things you should expect in a packet of biscuit include sharks, Hitler's *Mein Kampf*, or one of Nigel Farage's pubic hairs (framed, numbered and autographed).

'I wondered if it was a Willy Wonka kind of thing and I'd

won a tour of the McVitie's factory.'

James did not win a tour of the McVitie's factory.

No.8 POTHOLE MISERY: No new money to tackle weather-beaten roads in Oxfordshire

We're going to lay our cards on the table and admit that we are huge fans of Mark Morrell, otherwise known as Mr Pothole.

In a world of clueless angry people and self-appointed experts, Mr Pothole is a genuine expert who knows his stuff and isn't afraid to get out there – in any weather – to campaign for better roads.

Also, he creates great photo opportunities, as this little number from the *Oxford Mail* will testify.

What, he asks, if an oldie-wonk were to come up against a yawning great pothole on our roads?

Disaster, is the answer. Disaster.

The trouble being that nobody's got any money to repair potholes these days, so sooner or later, you're going to find a horizontal oldiewonk in the middle of the street, and we were warned.

He is the hero we all need, a hero in hi-vis. We should treasure him.

No.9 Farmer willing to use force to protect his Christmas turkey stock

We can't have an Angry People Top Ten without Christmas being ruined for somebody, and this is the most ruined Christmas we could find.

This farmer is sick of dogs ruining Christmas by attacking his turkeys, so he is more than prepared to use deadly force to make sure that your turkey arrives on your dinner table without unsightly tooth marks.

And, yes, you are saying 'Get orf moi laaaaand' in your head right now, which shows you have a latent prejudice against people who work our

land so that you can eat. You selfish bastard.

Kids: Keep your dogs under control in the countryside, it's not worth it.

No.10 Customer left flabbergasted by a Wigan baker's 8p sauce charge

Wigan is the pie capital of the world, so here's a gentleman who came over from Stockport and turned the entire town on its head by asking for a sausage butty.

And it came as something of a shock to our hero that he should be charged eight of Her Majesty's new pence for a squirt of H P Sauce.

As we all know, the only acceptable sauce on your sausage sandwich is tomato, and things were already on a downward spiral the moment he eschewed pie for some high-falutin' out-of-town snack. So some might say that 8p for a squirt of HP Sauce is everything he deserves.

But these people are wrong. Britain is a country of laws, the Magna Carta, and almost saying something when somebody pushes in front of you in a queue. So if our man wanted HP Sauce on his sausage butty, then he should have got HP Sauce on his sausage butty FOR FREE, as laid out in the Condiments Act of 1951, which I have just made up.

If bakers want to continually flabbergast their customers, then they are perfectly free to do so. But not on our watch. Free sauce for everybody, we say, and request sales folk quietly add 8p to the price of pie and we'll say no more about it.

Acknowledgements

This book would have got nowhere if not for the following people:

My partner Jane for putting up with me while I wrote this.

Amy McWalters, Fiona Crosby and Daniel Bunyard at Penguin for giving me the opportunity to write a book on a hobby that has taken over my life.

Becky Armstrong for skills.

The internet's Simon Harris, also for skills.

Simon Flavin from Mirrorpix for working miracles in photo research.

Barry Goodwin at The K M Group for similar.

Red Williams also for similar.

Lianne Ryan at Caters.

Adam Fradgley at Exposure Photography.

Anastasia Symeonides at Fairfax Australia.

Kerianne Mailman at News Corp Australia.

The S W N S picture desk in Bristol, who didn't think I was a nuisance in any way.

Steve Bailey and Nora Kernacs for the loan of their bin at a crucial point in the genesis of this book.

And this book would have been very empty indeed if it wasn't for the readers at the Angry People in Local Newspapers Facebook page.

Copyright Pages

Photos/Clipart

4. 'Yuk! There are maggots in my Fray Bentos pie' by Newsdesk © *Worcester News*

5. 'Couple's shock after "vegetarian" product incorrectly labelled' by Patrick McLean © *Wiltshire Times*

6. 'Family eat Quality Street Christmas dinner after pub "ruined" festive day' by Eve Buckland © *Wiltshire Times*

7. 'Father's disgust at rubber dummy in bag of Iceland rice' by Chris Humphreys © *Swindon Advertiser*

8. 'Fury after Morrisons wouldn't sell couple meat pies before 9am' by Keane Duncan © *Gazette Live*

Transport

1. 'Fury at plans to spend £54,000 on bus signs' by Chris Elliott © *Cambridge News*

2. 'Learner driver mum slams "crazy motorists" for driving her nuts' by Samar Maguire © *Cambridge News*

3. 'Train enthusiasts call for "wave of carnage" ticket office closures to be reversed' by Ben Welch © *Epsom Guardian*

4. 'Bus stop labelled "ridiculous" after council workers paint lines across driveway' by Andy Baber © *Wiltshire Times*

5. 'Cyclist lies down in "absolutely ginormous" pothole in Plympton' by Katie Timms © *Plymouth Herald*

6. 'Angry people meet to discuss parking problems around Devonport Dockyard' by Jon Lewis, Katie Timms © *Plymouth Herald*

7. 'Couple lose £1,200 Las Vegas break after booking flights from WRONG Birmingham' by Alison Stacey © *Birmingham Mail*

8. 'Man furious over "poorly kept" traffic island' by Robin Murray © *Wiltshire Times*

Crime

1. 'Sunday trade moves are Satan's work says cleric' Newsdesk © *Guernsey Press*

2. 'Not again! Jeremy Corbyn TEDDY vanishes' by Tom Edwards © *Worcester News*

3. 'Devon mum installs CCTV because yobs throw

ONIONS at her house' by Anna Farley, Jamie Hawkins © Devon Live

4. 'Hull pensioners' fury as they are "plagued" by scammers' by David Spereall © *Hull Daily Mail*

5. 'Naked gardener "puts neighbour off sausages"' by Get Reading Newsdesk © Get Reading

6. 'Anger as thieves posing as workmen steal paving slabs' by Alex Grove © *Hull Daily Mail*

7. 'Huge arrow shot at house in Worcester' by Robert Hale © *Worcester News*

8. '"Senseless vandalism" as trees snapped within hours of being planted' by Hannah Mirsky © *Cambridge News*

9. 'Traffic cone man slams court appearance as "ridiculous"' by James Connell © *Worcester News*

10. 'Cornwall woman's anger after car vandalised outside her own drive' by Graeme Wilkinson © Cornwall Live

Anti-social News

1. 'Butcher warned by police to tone down risqué signs by Becky Loton © *Stoke Sentinel*

2. 'Residents demand action on area plagued with worst dog poo problem in town' by Lewis Clarke © Devon Live

3. 'Ball bombardment leaves west Belfast woman "a nervous wreck"' by Mary Louise McConville © *Irish News*

4. 'House fire started by a squirrel disrupts funeral procession' by Ramzy Alwakeel © *Romford Recorder*

5. '"Angry church seagull keeps attacking me and all I want to do is play Pokémon Go" says Devon man' by Alex Richards, Lewis Clarke © Devon Live

6. 'Concerned parent says "disgusting" dog mess is being left around village' by Hannah Worrall © *Worcester News*

7. 'Woman living on building site after eighty neighbours move out' by Connor Dunn © *Liverpool Echo*

8. 'Family scare as fox gets in through cat flap' by Swindon Advertiser Newsdesk © *Swindon Advertiser*

9. 'Bird scarer is driving us (and our dogs) round the

bend!' by James Connell © *Worcester News*

10. 'Postie cries foul over language of pranksters' by Sarah Taylor © *Worcester News*

11. 'Catford fox horror for man on toilet' by Sarah Trotter © *News Shopper*

Money

1. 'I'm so angry that charity shop didn't let me buy blouse' by James Savage © *Worcester News*

2. ' "That's disgusting" – grandmother's horror at dirty stains on mattress' by Tina Robins © *Swindon Advertiser*

3. 'Here's my parking fine – in 1p pieces' by Wiltshire Times Newsdesk © *Wiltshire Times*

4. 'Father's shock as he sees £500k overdraft after having bank account frozen' by Josh Walton © *Brighton Argus*

5. 'Repentant passenger fined "outrageous" £600 for £4 train fare dodge' by Chris Binding © *South Wales Argus*

6. 'Hull man's anger as he is fined for visiting Asda twice in one day' by Phil Winter © *Hull Daily Mail*

7. '*Grange Hill* star's business struggling after online banking "fiasco" ' by Andy Datson © *Croydon Advertiser*

Council Issues

1. 'Council accused of wasting energy as office lights are "left on all night" ' by Charlotte Becquart © *Cornwall Live*

2. 'Pensioner rages at "ghastly" four-foot ditch left outside his home' by Lottie O'Neill © *Essex Live*

3. ' "My beloved dog Snowy will be torn apart by foxes if council chop my fence in half" ' by Alex Grove © *Hull Daily Mail*

4. 'Anger as dog walkers steal second sign in two days from Devon beach' by Joel Cooper © *Devon Live*

5. 'Woman fears giant tree is going to crush her house' by Lauren Haly © *Plymouth Herald*

6. 'Residents want to bring an end to thorny battle with Wiltshire Council' by Robin Murray © *Wiltshire Times*

7. ' "I told the council about dangerous paving two years

ago – and it's still not fixed"'
by Alex Douglas © *Hull
Daily Mail*
8. 'Field looks "like the
Somme" after developer
changes land' by
Jenny Seymour
© Get Surrey
9. 'Newly fitted lights could
harm children's eyesight'
by Richard Vernalls
© *Worcester News*
10. 'Smelly bin taken away after
a year' by Joel Adams
© *Brighton Argus*

**The Top Ten of Angry People
in Local Newspapers Photo
Credits**

1. © *Manchester Evening News*/
Mirrorpix
2. © *Reading Post*/Becky Draws
3. © Nelson Weekly, NZ
4. © *NT News*, Australia
5. © Royston Crow
6. © Kent Online
7. © *Portsmouth News*
8. © *Oxford Mail*
9. © *Hull Daily Mail*
10. © Andy Sokill/*Wigan
Observer*